spirit
OF color

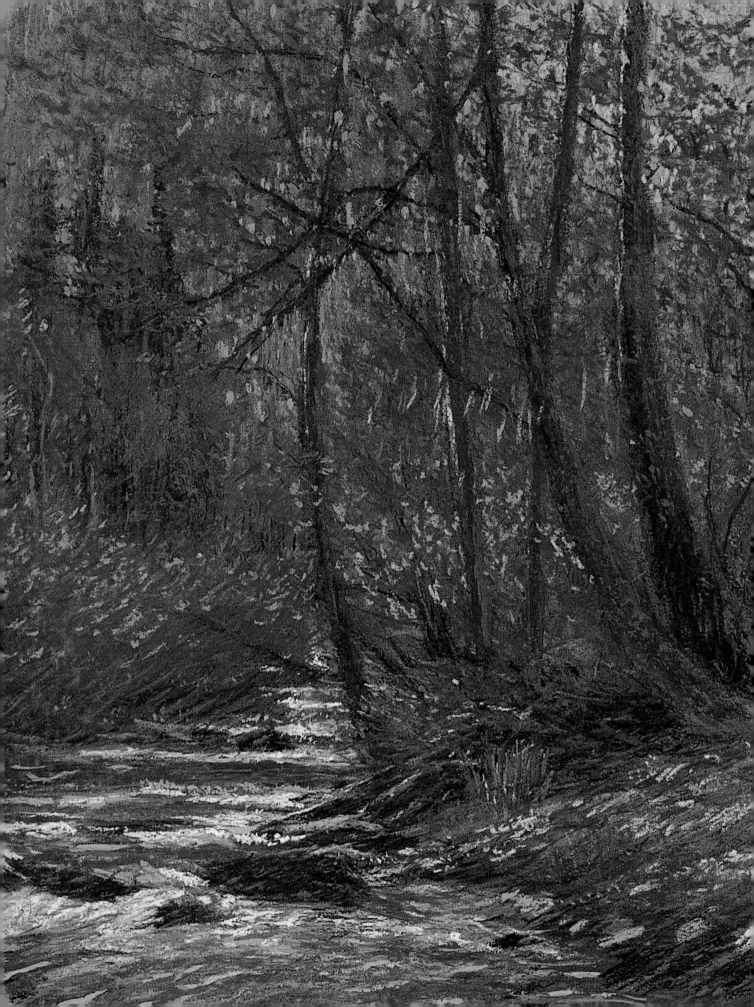

spirit
OF color

A SENSORY MEDITATION GUIDE
TO CREATIVE EXPRESSION

CONNIE SMITH SIEGEL

Watson-Guptill Publications/New York

Executive Editor: Candace Raney
Editor: Martha Moran
Production Manager: Alyn Evans

Published in the United States by Watson-Guptill Publications, an imprint of the Crown Publishing
Group, a division of Random House, Inc., New York.
www.crownpublishing.com
www.watsonguptill.com

Watson-Guptill Publications books are available at special discounts when purchased in bulk for
premiums and sales promotions, as well as for fund-raising or educational use. Special editions or
book excerpts can be created to specification. For details, please contact the Special Sales Director.

Library of Congress Cataloging-in-Publication Data

Siegel, Connie Smith.
 Spirit of color : a sensory meditation guide to creative expression /
Connie Smith Siegel.
 p. cm.
 Includes index.
 ISBN-13: 978-0-8230-9911-5
 ISBN-10: 0-8230-9911-3
1. Color in art. 2. Color—Psychological aspects. I. Title.
 ND1495.P8S54 2008
 701'.85—dc22

 2008017094

ISBN-10: 0-8230-9911-3
ISBN-13: 978-0-8230-9911-5

Printed in China

10 9 8 7 6 5 4 3 2 1

First Edition

acknowledgments

As in my first book, *Spirit of Drawing*, I have been inspired and sustained by a large web of support, from early teachers to university mentors and fellow artists. I am especially grateful to my university mentor Roland Reiss, who loved color and introduced me to Johannes Itten's book. I have been inspired by the structural integrity of Richard Conklin's paintings and by Art Holman's masterful use of light and color. I am grateful for my long-term Sensory Awareness meditation teachers, Charles Brooks and Charlotte Selver, as well as Buddhist teachers Trungpa Rimpoche and Jack Kornfield. Artists/therapists Natalie Rogers, Virginia Veach, and Leon Siegel helped me to access and understand deep feeling states.

I am grateful for the many students who have worked with me over the years—especially those long term participants who have become my real teachers and creative family: Lynnelle, Patrick, Jackie, Regina, Ayumi, Carol, Kay, Susan, Patricia, Jean, Jan, David Miller, David Newell, Beatrice, Audrey, Gael, Alisa, and the many others whose work appears in this book. Seeing their evolution over a period of time in the context of the color contrasts has given me an appreciation for the power of individual differences and for the interconnection between artistic, emotional, and spiritual growth.

I wish to thank the museums and agencies that provided the master drawings and paintings, and Lynn Scott and Linda Moore who assisted me in obtaining these images. Many editors and technicians have contributed to the production of this book. I am especially grateful to the long-term support of artist and graphic designer Linda Larsen, and to Leila Joslyn, the fine graphic designer who worked closely with me in further developing the book. I have appreciated the technical assistance of Robin Collier, along with photographers Jay Daniel and Bea Benjamin, and printer Steve Kimble. Editor Julia Moore has provided important insight and support.

I appreciate the expertise and experience of editors Candace Raney, Martha Moran, and designer Areta Buk at Watson-Guptill Publications who have expanded the book in significant ways.

Throughout it all, the intimate connection with the natural world through drawing and painting has deeply inspired my creative evolution. The meetings of light and color in hills, forest, ocean, and the high Sierra have become metaphors for different aspects of myself, reminding me of the abundance of my own nature.

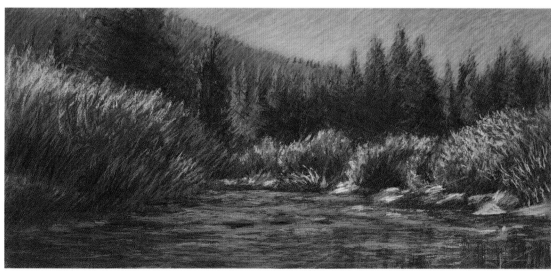

Connie Smith Siegel, *Sierra Willows*, 14 × 31½ in., 2004

contents

introduction

*It is thus a color which is not . . .
a realistic "trompe l'oeil" but a color
that suggests one sort of emotion,
a passionate temperament.*

Vincent van Gogh

This book follows a journey that began as a personal search for the elusive magic of color in my own work and expanded into a lifetime of teaching—exploring this magic with many others. The journey took me on wildly unpredictable adventures, some seemingly outside the realm of art: healing, spiritual practice, and even political activism. But no matter how far ranging, these adventures were always supported by a system of objective color theories and inspired by the drawings and paintings of past and modern masters.

In *Spirit of Color*, I have integrated these intuitive and objective aspects of color into a comprehensive guide to expressive color—uncovering the inner source of color through meditation and carrying its evocative power into drawing and painting media.

Although our exploration can lead to fuller expression in any medium, the intent of this book is not so much about generating a work of art but more about discovering oneself through the magic and mystery of color. In many ways, you already know everything you need to know about color. Creative expression is innate in all of us, and color is a universal language we all possess. In this book I'll show you how to reveal the spirit of color that lies deep within, no matter what your experience or skills. This spirit will spontaneously find expression in your life and art.

Each chapter in *Spirit of Color* is built on the next, and each explores a different aspect of color expression. The first three chapters provide an opportunity to focus on the evocative power of color—finding personal color harmonies with the same ease and familiarity as choosing clothes. At the same time, you will discover that your inherent color sense is not only personal but also part of a universal, elemental vocabulary that reflects all the elements of the natural world—the pervasive qualities of earth, air, fire, and water.

In the remaining chapters we will expand this elemental language as we explore the widely accepted color theories of Johannes Itten, from his book *The Art of Color*. When approached in the spirit of adventure, the structure of Itten's contrasts can deepen your process of self-discovery. You can follow the passionate journey of artists such as van Gogh, whose searches led him away from the earthy glazes of Rembrandt, to the Impressionist shimmer, to Gauguin's flat abstractions in the pursuit of his personal vision. As you identify with the different artists presented in the book, you can find your place as well. Through this intimate link with this family of artists, you will understand the source of expressive power and magic in master paintings, from the inside out.

The progressive sequence of learning in the experiments in the book can lead to more effective expression in color—clarifying elusive visual effects and solving problems in composition and pictorial unity. But even as we find answers to important questions, our exploration can also intensify the mystery. Whatever agenda we might have for color expression, the agenda of color itself is much stronger—it offers magic on its own terms. In the end we can only learn to follow the call of color—an energetic force that reflects the unseen rhythms of the universe. Although we can find important ways of coming into alignment with this force, we cannot control it. But as we come to trust the immensity of color, we can fulfill the promise of our own natural powers—our sense of oneness with the cosmic world.

Jan Gross improvisation, pastel on blue paper, 22 × 30 in., 2007

We learn to trust the immensity of color—an energetic force that reflects the rhythms of the universe.

What we need to be taught is not art
but to believe in ourselves, our
imagination, our senses, and our
hands, to free our bodies and spirits
that we may live and work according
to our visions.
Florence Cane, *The Artist in Each of Us*

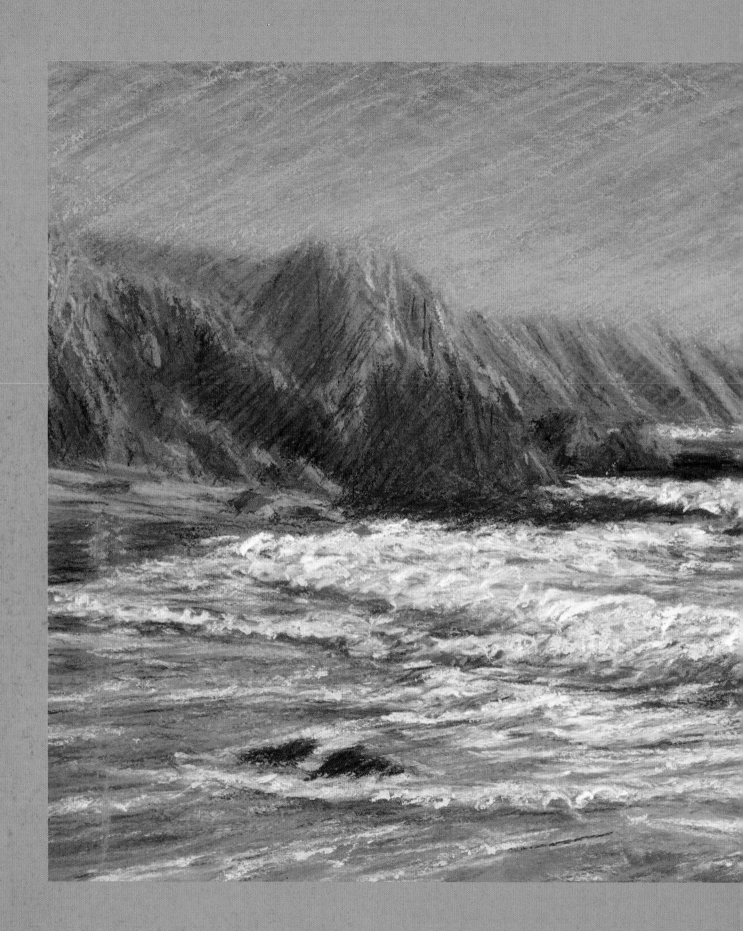

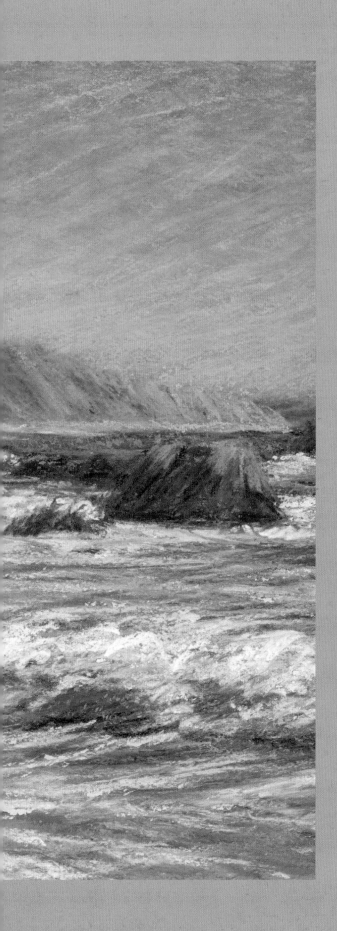

the creative source: a personal journey

This book weaves together many experiences—my connection with nature through drawing and painting, the meditation practice of Sensory Awareness, Gestalt and Expressive therapies, Buddhist meditation, and psychic studies. As a long-term university teacher of drawing and color, I have been deeply influenced by the color theories of Johannes Itten and his seven Color Contrasts and inspired by the work of past and current masters, as well as the work of mentors, colleagues, and students. The following account of my personal journey into color will help you more fully understand the theories and practices that are the foundation for *Sprit of Color*. By telling you about my color journey, I hope to inform your own.

Connie Smith Siegel, *Late Afternoon McClure's Beach* (detail), pastel, 12 × 30 in., 2005
Through color and drawing we connect with elemental forces.

the meeting of intuition and theory

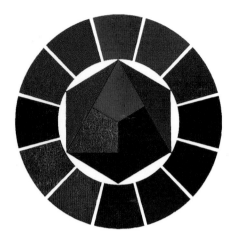

12-hue Color Circle, from Johannes Itten, *The Art of Color*, © 1961 Otto Maier Verlog Ravensburg. Reprinted with permission of John Wiley & Sons, Inc.
Johannes Itten's color wheel.

Colors are the children of light and light is their mother.

Johannes Itten, *The Art of Color*

As a child I loved to go though a portfolio called the *World's Best 100 Paintings*, learning each of the artist's names, styles, and their place in history. There was one painting that especially spoke to me—a golden Tahitian landscape by Gauguin that seemed to light the room. This painting, along with others, haunted me as I later searched for this magic in my own paintings. Through the support of many teachers who shared their love of color and the importance of abstract composition, I gradually came to find my own creative style.

In 1962, just before graduating with an MFA from the University of Colorado, I experienced very exciting breakthroughs with color in my own painting, but I was daunted by the prospect of teaching others. Fortunately, I found a wonderful new book on color called *The Art of Color*, by Johannes Itten. The first few pages were thrilling: distinctive checkerboard squares of color with photographs of the student/artists beside them, highlighting their uniqueness and individual differences in the ways they saw, used, and experienced color. At last, here was a book written for artists that presented individual color harmonies as the source of personal style. I had been searching for years to find a book on color that could illuminate the magic I saw in the paintings of past and modern masters. Sometimes this magic appeared in my own work, but it could disappear just as quickly as I kept painting. What was the real source of the resonant color of Gauguin, van Gogh, and Matisse?

I had been disappointed with other books on color and their emphasis on the harmonic, soothing principles preferred by interior decorators. The system of color contrasts presented by Itten is about the vital interaction between forces, a visual excitement that must be contained within a frame, not spread out all over the house on curtains, rugs, and slipcovers.

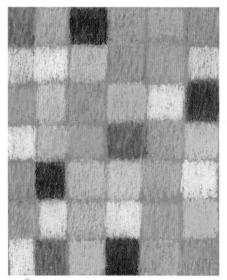

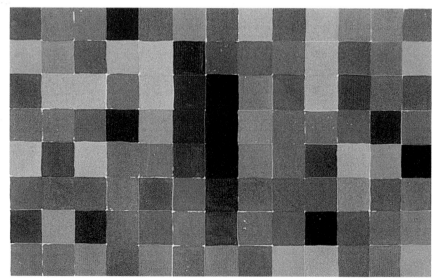

Connie Smith Siegel, checkerboard, *Winter, Spring*, (details), pastel and gouache, 8 × 10 in.
Checkerboard squares can reflect individual color harmonies, as well as archetypal qualities such as the seasons or the four elements. This simple design, used frequently in the *Art of Color*, allows us to focus on color.

This system of color interactions enabled me to continue my search with others as I started teaching, and it answered many questions about the dynamic color of past and modern masters. The wide scope of the Itten color system has carried me through decades of teaching, as I observed the great diversity of styles in students and colleagues. Whole creative communities have evolved from this common language of color, which allowed us to see each other and our individual preferences more clearly. By presenting this system of color contrasts with an emphasis on the elemental qualities in *Spirit of Color*, I am continuing this evolving community.

Colors are forces, radiant energies that affect us positively or negatively, whether we are aware of it or not. The effects of colors should be experienced and understood, not only visually, but also psychologically and symbolically.

Johannes Itten, *The Art of Color*

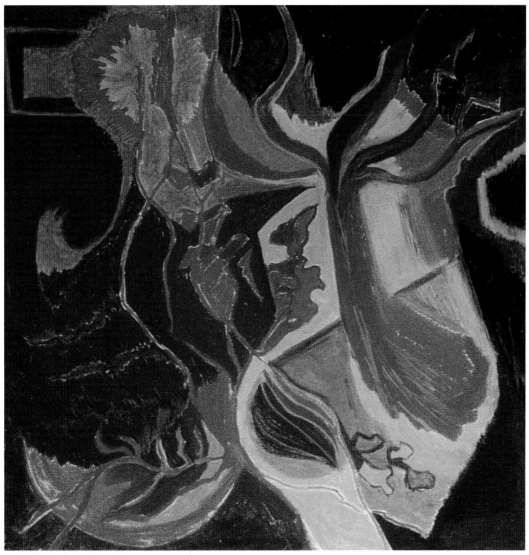

Audrey Wallace Taylor, oil pastel

The different color contrasts of Itten are like trails in the wilderness, leading us to unexplored places. Through this study Audrey has accessed the element of fire, an invitation to use color at its fullest intensity, extravagant and abundant.

the inner source of color

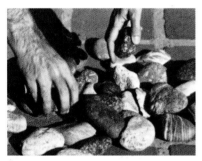

Charles Brooks, photograph (from the estate of
Charles Brooks), detail
After choosing stones, we took time to
experience their texture and weight.

As helpful as the study of Itten's color contrasts can be in developing aesthetic effectiveness, it is important to move more deeply into the source of the creative power of these contrasts. Beyond the traditions of art, I discovered a more basic reality of color. It is an untamed, primal language, fully developed in everyone and universally understood, even without formal study. The full consciousness of this natural language came only after I left the university, with its emphasis on visual traditions and finished products.

As I deepened my involvement with disciplines of meditation and personal growth, I became more aware of the nonvisual sensations of my inner world. Experience with Buddhist meditation, the practice of Sensory Awareness, Gestalt therapy, personal therapy, and expressive art therapies all contributed to a new understanding and acceptance of my own basic impulses and the ongoing mysteries of my own emotions.

Sensory Awareness as an Inner Source

The practice of Sensory Awareness, especially, was an essential entrance into the world of sensory meditation, and it gave me an opportunity to actually experience some of the meditative states I had been studying in books.

I found this practice quite unexpectedly on a summer drawing excursion to Monhegan Island, a wilderness of cliffs and forest off the coast of Maine—a vast expanse of ocean, wildflowers, and blazing white surf. When the vistas were covered by a dense gray blanket of fog, I found myself drawn to the details I had missed before—the intricate patterns of barnacles around the edge of tide pools and the delicate undergrowth on rock crevices.

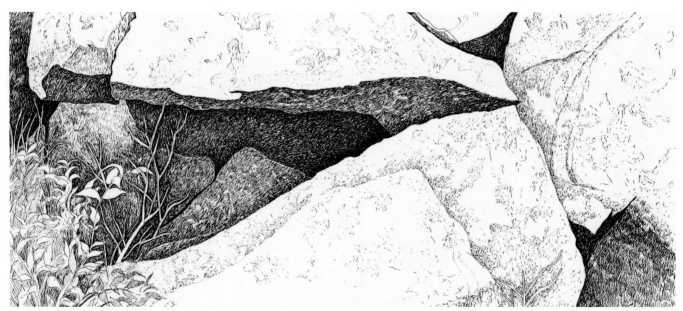

Connie Smith Siegel, Monhegan rock crevice, pen and ink, 9 × 22 in., 1966
In the fog I found myself drawn to intricate details—deep rock crevices that seemed to open into the center of the earth.

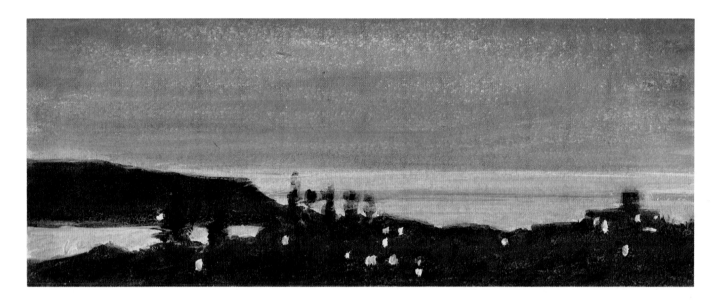

After weeks of immersion in the intimate world of these natural forms, I was curious enough to join a workshop with the provocative title "Sensory Awareness." Taught by Charlotte Selver and Charles Brooks, it was a study of consciousness, emphasizing direct perception as distinct from intellectual or conceptualized knowledge. The first class challenged the concepts of learning I held as a university professor when Charles declared he had nothing to teach. Instead of the useful exercises I expected, he and Charlotte offered deceptively simple "experiments," with no goal in mind but awareness. The atmosphere in the classes echoed the quiet attention of Buddhist meditation, but instead of the common ritual of sitting practice, we became aware of our inner responses through more ordinary activities such as lying, bending, and coming to a standing position. These simple explorations brought my attention further inward as I experienced the movement of breathing, the distinctive smell and touch of the grass mats on the floor, the texture and weight of the gray and white stones brought in from the island coves. Walking on the wooded trails after the classes, I experienced the island in a new way—sounds, smells, and tactile sensations became more vivid: the comforting smells of old-growth forests and the pungent odor of seaweed at low tide and the sounds of the foghorns echoing across the island. My sense of seeing felt closer to touching, as I noticed, as if for the first time, the luminous grays in the rocks and lichen, the iridescent green moss shimmering against the fallen leaves on the forest floor. The subtle shifts of light on the ocean were especially vibrant as our group watched sunsets together, savoring each change of color until the last fragment of sun disappeared in the twilight.

Connie Smith Siegel, Monhegan sunset, casein, 4 × 10 in., 1968

We watched sunsets together in a seeing meditation, noticing all the different stages as day moved into night.

meditation into art,
a new approach to learning

Liana Kornfeld, charcoal, 18 × 24 in. © Liana Kornfield

The sense of weight has a strong influence, from the experience of weight on the paper to lifting a stone to seeing and drawing the stone.

The subtle but powerful work in perception, along with experience in Buddhist meditation practice and Gestalt therapy, influenced my life and teaching to such an extent that in 1972 I left the university for a yearlong study group in Sensory Awareness. When I explored drawing with fellow members of the study group, I integrated my university exercises in drawing with sensing experiments—finding the source of drawing in the sensations of touching, movement, weight, and space. As we worked, I gave up my role as an all-knowing teacher to that of a fellow traveler, exploring together, destination unknown.

I was amazed at how closely our discoveries paralleled the exercises of Kimon Nicolaides, whose book *The Natural Way to Draw* had been the guide in my university classes. Instead of exercises, we worked with simple experiments in perception, trusting our direct experience. Starting from the inside out with the same perceptual principles, we evolved the processes that eventually led to my previous book on drawing and meditation, *Spirit of Drawing*.

As I explored color with the Sensory Awareness study group and later in contexts of healing and expressive art therapy, I was amazed to find the distinctive color harmonies inherent in Itten's color theories emerging spontaneously from inner states of being, without prior study or intention. The personal shapes and color choices were not only distinctive to each person, but revealed a fully formed, natural language of emotional states. I realized the Itten system was a mirror of human emotion. And like any great work of art, the color expression moved beyond the individual stories and subject matter into the archetypal forces of the world—the energetic qualities of earth, air, fire, and water—a living language we share with all beings.

Our actual knowledge of the unconscious shows that it is a natural phenomenon and that, like Nature herself, it is at least neutral. It contains all aspects of human nature—light and dark, beautiful and ugly, good and evil, profound and silly.

C. G. Jung

Katherine Delazlo, oil pastel (above left); oil pastel (above)

The full-bodied experience of life force during pregnancy evokes the elements of fire and earth (above left). This powerful drawing was followed by a more reflective drawing (above), evoking water and air. This second drawing brought a natural balance of forces.

the transformative power of color

Watching the powerful balancing process of color in the context of life events revealed a whole new dimension of the elemental power of color. It is these subconscious, emotional qualities that carry the magic of color, the impelling, insistent vitality that seems to call us across the room and takes our breath away. Drawings and paintings that radiate this inner force are not just illustrating reality but creating reality right under our eyes. These arrangements of colored pigment can change us at very deep levels, can take us from our smaller reality into larger powers.

Knowing this transformative power of color, it is no accident that Matisse brought his paintings to his friends who were sick. He was fully conscious of the healing potential of color. The fierce dedication to a fuller experience of living through color led him to his innovative explorations, considered outrageous at the time. His paintings were often criticized and dismissed, but he was compelled by the life force he experienced when color was released from the need to depict detail.

Although Matisse inherited the sense of clarity and order of the French tradition from his masters, Poussin and Cezanne, he felt it necessary to turn away from their complexity and refinement. He returned to the beginnings of human perception, to pure color, shape, and movement, to materials that stir the senses, and to elementary principles that give life by coming alive by themselves.

In the end, the spirit of color is about healing and transformation for us and for others. The complete dedication of Matisse to both exploration and excellence within the art tradition brought the healing power of color into visible form. Because of his dedication and of others before and after him, the possibility of transformation through form and color is more available to all of us. The door has been opened—color has been released from representation—and each of you, no matter where you are in your creative process, has the creative power to transform your art and life with very simple means.

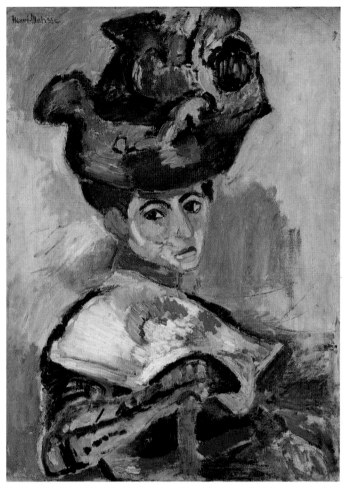

Henri Matisse, *Woman With a Hat*, oil on canvas, 31¾ in. × 23½ in., 1905. San Francisco Museum of Modern Art, Bequest of Elise S. Haas. © 2008 Succession H. Matisse, Paris / Artists Rights Society (ARS), New York.

Matisse's wife, Amélie, who posed for this early portrait, supported him in his choice for intensity and life force when she declared, "I'm in my element when the house burns down." She was speaking of Matisse's pictorial conflagration that had struck the public as the work of a deranged lunatic. The organization of primary color that maintained this intensity resulted in the Fauve movement.

Colors have a beauty of their own which must be preserved, as one strives to preserve tonal quality in music . . . Fauvism for me was proof of the means of expression: to place side by side, assembled in an expressive and structural way, a blue, a red, a green. It was the result of a necessity within me, not a voluntary attitude arrived at by deduction of reasoning; it was something that only painting could do.
Henri Matisse, *The Role and Modalities of Color*, 1945

the map of exploration:
a summary of *spirit of color*

To explore the transformative possibilities of color we will follow a progression of experiments I have used in color workshops given over the years—in university classrooms, or along a forest stream, or on the side of a hill. Before working with the color theory, we always take time to explore intuitive color choices, allowing color combinations to emerge spontaneously, with nothing in mind.

These intuitive choices can be seen as COLOR CHORDS—arrangements of colors that have a certain resonance, a particular feeling quality, like the different movements in a sonata. These arrangements can be created without any instruction or expectations, revealing aspects of your inner nature that may be hidden to your conscious mind. Through the apparent randomness of your choices, you can recognize the inevitability of your preferences and the strength of your own gifts.

This natural language of color becomes even clearer when you express something from life and discover that everything in our lives has its equivalent in color. Because life events demonstrate an elemental language, we will explore the elements themselves—air, earth, fire, and water—experiencing them inside, visualizing and choosing a color chord for each. As we draw from each element it becomes clear how closely our emotional impulses, as well as composition, are related to the different elements. After this exploration, the Itten contrasts can give a structure to the natural language of color you have discovered, allowing you to appreciate your own gifts and to identify a family of artists you might feel an affinity with. This study can also help in maintaining your personal color harmonies if you decide to work from the figure, still life, or landscape.

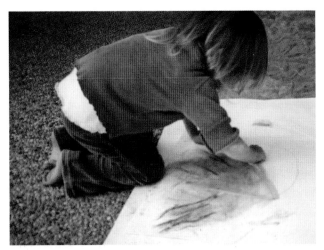

Children are our best models for visual improvisation, in their passionate attention and absolute trust in the process. With confidence and complete absorption, this child is inventing her technique as she goes.

EXPERIMENT: Improvising with Color

The experiments throughout the book are best experienced in the order presented. Before beginning these experiments, you may want to take some time to explore some of the basic materials, especially if you haven't worked with them yet. When you take a color out of the box of crayons or pastels, notice how it resonates with you and where it wants to land on the page. Does this color invite others to join it? With your selection of drawing materials, oil pastels, and paper, work as if you were exploring a new wilderness area, led by curiosity alone. This exploration may take a few minutes, or continue for hours or days. When you try the experiments in the rest of the book, it will be a continuation of a creative adventure you have begun.

Here is a list of the materials you will need to conduct this experiment:

- Box of oil crayons and/or soft pastels (24 or more)
- Soft pencils (5B, 6B), charcoal, Conté crayon
- Pad of 18 × 24-inch rough newsprint or bond paper
- Pad of Bristol paper
- Sheets of colored paper
- Kneaded rubber eraser

For more detail on these and other drawing materials, see pages 166–173.

ABOVE: Regina Krausse, *Color Improvisation, 1, 2, 3*, oil crayon, 18 × 24 in.

As each color enters the page, notice what colors come to answer it. With the confidence of a child, Regina has made a visual improvisation, allowing one color to lead to the next, trusting each step of the journey.

LEFT: Jean Woodard, improvisation with oil crayon (detail), 11 × 17 in.
Jean is exploring line and color, just for the joy of it.

the inner language of color

Matisse spoke of colors having a beauty of their own, which must be preserved as one preserves tonal quality in music. As he gave up the specific detail inherent in the Western tradition, his color achieved a life of its own, not only describing the world but also recreating it. Because this powerful force is often neglected, in this chapter we will explore the intrinsic quality of color alone, using very simple methods to create color "chords"—specific color combinations, which can touch us as music does. These combinations reveal a universal language that we possess, just by being alive.

Beatrice Darwin, *Friday Morning—An Orange, Pewter Trays*, paper collage
The colors of everyday objects inspire a collage.

color as a natural language

The basis of the color pile is the Color-aid full set of interrelated colored papers, arranged in their proper order on the color wheel (see page 174 for details about this color system.

Exploring color might be more familiar to you than drawing, because color is a part of our everyday lives. Whether we're buying greeting cards or cars, choosing flowers for special occasions, decorating our homes, or deciding what to wear, we all make color choices daily. The choices reflect individual preferences or conventional trends, such as blue jeans or gray suits, or pink and blue for babies. We associate the contrast of red and green with Christmas, black and orange with Halloween, and pastel colors with Easter.

We use color to describe emotional states, feeling "blue" when we are sad, "seeing red" when angry, or feeling a "purple passion" when romantically in love. Red, white, and blue can evoke a patriotic love of country, red and black can prepare us for conflict, and rainbow colors symbolize harmony and peace. These are subjective responses, but they often have their basis in human perception. Scientific experiments have proven that we are physically affected by color, from the calming effect of blue-green to the stimulating action of red-orange (which can even raise blood pressure).

Although we all are influenced and touched by color in our lives, when it comes to art many of us are convinced that we have no sense of color. Even Matisse once wrote, "It is clear that one must have a gift for color, as a singer must have a voice." This has not been my experience; as a teacher I know that the "gift" for color is abundantly present in everyone, artists or not.

To reveal these innate gifts for color expression, we will do several experiments that explore the use of color as meditation, focusing on the pure vibration of color alone. Although you may have used color in your drawing experiments, working in color without drawing can clarify your unique sense of color and help you redis-cover a vast natural language that you've always known.

EXPERIMENT: Exploring with Color-aid Papers

We begin with the deceptively simple process of simply choosing colors from a pile of Color-aid papers, which are sold as a packaged, balanced set of specially printed colored paper cards. (For more details, see page 174.) When used for commercial purposes, the squares of color are best kept in their box, carefully organized. For our creative purposes, however, take the colors out of the box and mix them up, unleashing the original energy of the colors as they fall, unordered and chaotic. Out of this chaos the colors will find another kind of order.

This large assortment of colors has a powerful presence and can evoke many responses, from a sense of excitement to a quiet reassurance. Reaching into this pile to choose your colors can be like an excursion into nature—the simple act of seeing and choosing colors is a spontaneous meditation in itself that can awaken us immediately to natural forces. But to experience your color choices more fully, I suggest you spend a short time of preparation, inviting a sense of quiet awareness.

When the Color-aid papers are released from their original order in the color selector, they attain a life and presence of their own. Seeing these colors in a state of chaos can be like an excursion into nature, offering a multitude of choices. Out of this chaos your intuition can find a new kind of order.

Christopher Hobbs, color chord, paper

Harry Collimore, color chord, paper

Harry Collimore has built a monument to stability and balance, including all the elements of earth, air, fire, and water (bottom). By contrast, Christopher Hobbs leaves many colors behind in his search for the most exciting vibration (top). Both found what they needed.

EXPERIMENT: A Meditation for the Eyes

Before looking at the color pile, close your eyes and notice what you are feeling in this present moment. What sensations do you feel between the soles of your feet and the top of your head? Do you notice any sensation in the space inside your head? Feel where your eyes are in this space, and allow them to be more at rest.

Cover your eyes with your palms, noticing what your own touch brings. Stay this way as long as it is comfortable. As you bring your hands away from your closed eyes, notice the gradual increase of light. Can you be receptive to the light coming through your closed eyelids?

With open eyes, notice what it is to see after this time of quiet. Is it possible to remain receptive even when your eyes are open? When you are ready, let your eyes rest on the pile of colored papers, noticing the effect these many colors might have on you. After a while, do some colors begin to stand out more than others?

Seeing so many colors together can be like seeing a room full of people. First we notice the size and extent of the whole crowd and then we gradually make distinctions within it. Who are we drawn to? Do the choices come from familiarity, excitement, habit, or curiosity? Whatever the reasons, we find ourselves in conversation with one person, or several, and one interaction leads to the next. It can be the same with your color choices.

EXPERIMENT: Choosing Your Colors

Picking colors from a color pile can become a kind of inner conversation as you begin to interact with the color harmonies you might be seeing.

Spontaneously choose colored papers from the pile. As you reach into the pile of colored papers, let yourself be drawn to whatever attracts you, trusting whatever comes into your hands, any combination of colors, any number. The colors may even seem to choose you as you are led irresistibly to what you want. One color follows another, resulting in sometimes unexpected, yet compelling, combinations. It is important to accept anything that happens; there is no need to produce anything meaningful or beautiful. There are no wrong combinations, and there is no one right way to achieve them.

As you select the colored papers, put them on a sheet of white paper. Arrange them carefully, or simply leave them just as they came off the pile. Even without conscious intention, *as you experiment*, the colors can seem to arrange themselves in a few seconds with an amazing exactitude, each color square finding its place in relation to all the others. This simple process of arrangement happens almost involuntarily. It is very close to doing nothing, and yet as we view the colors later, we can see that a great deal has happened.

From the whole spectrum of color possibilities everyone invariably chooses their own unique combinations—each a world in itself, each with its own distinctive form, resonant in its own particular way. These combinations can be described as "color chords," unique color harmonies that reflect the myriad qualities of the world.

These myriad qualities were evident when a group of friends and family chose color chords after a Thanksgiving dinner. Displaying a similar appetite and curiosity for the colors as for the food courses, each person followed his or her own creative path. Seeing the color chords all together later was like an excursion into nature. We were astonished at the wealth of individual variations. No matter what age or experience with art, each person was masterful in his or her unique color expression. Like a visual emotional weather report, the language of color reveals changing states of being with an uncanny accuracy, expressing how we feel at the moment.

The sensations of colors on the palette become experiences of the soul.
Wassily Kandinsky, *Reminiscences*

Ayumi Kie Weissbuch, series of three color selections, paper

Ayumi Kie Weissbuch's three color chords, chosen one after the other, reflect a movement from a dark chord, expressed in black and dark blues, that moved to a lighter mood of light greens to the joy of a full spectrum of colors.

color chords reflecting your world

A series of individual choices emerges from the chaos of the color pile, reflecting different states of being for Pat Maloney. We can see the movement from a weighty dark block (top) to bright hues (center) to a subtle harmony (bottom), bringing balance.

Every emotion and every quality of being has its equivalent in color, and the colored papers can make the changing aspects of our lives immediately visible. Now we can begin choosing a series of two or three color chords.

EXPERIMENT: A Series of Colors
Changes can be apparent when we follow our first choice of colors with a second chord of colors, and then a third. The random color selections may seem accidental, and yet when we are done, orderly patterns of movement between the sets can become evident, seeming intentional. Bright colors are often balanced by more subtle ones—warm follows cool, and light is balanced by dark. We can see all the changing aspects of nature reflected in these colored papers, from the full spectrum of sunlight moving into twilight and dark, to summer moving to fall and winter. Whether subtle or dramatic, our color choices are always changing.

For example, notice Pats's color choices (left) from a healing process, which moved from a dark block of frustration he was feeling into an outgoing, assertive primary statement, and ending with a quieter, more reflective harmony.

Expressing Life Events Through Color

Colors chosen often spontaneously reveal fundamental aspects of our inner life that may be hidden to the conscious mind. If we choose colors with specific life occurrences in mind, we can see how naturally we use this elemental language of color and begin to appreciate the wide range of color expression available to us.

EXPERIMENT: Expressing Life Events Through Color
Begin with eyes closed, or resting, noticing sensations of the present moment. Then, invite a memory or a current situation in your life into your consciousness. It might be something particularly intense, or something quite ordinary. It could be from the distant past, or something that is happening in the moment. Just notice what comes to you right now, trusting any response you might have. Does the thought of this particular life situation bring a certain quality of feeling and a color or colors that accompany the feeling? Let these colors resonate inside you, and when you are ready, choose them from the pile of colored papers, trusting anything that you are drawn to.

After you have chosen the color papers, you may want to draw from them as well, letting the energy you feel lead you in a spontaneous expression. Trust whatever you find yourself doing.

Blues and greens evoke the element of water and the serenity of an ocean marsh in Jackie Kirk's paper selection (above) and drawing (right).

It can be astonishing to discover that particular life circumstances or events call up distinct color resonances: The calming memory of a distant place evokes the element of water (above), while the frustration of a leaking roof or a traffic ticket evokes fire (below).

Notice the curving forms that emerge naturally from the elemental quality of water evoked by the color chord. In contrast, the color chord with the qualities of earth and fire spontaneously leads to an explosive drawing full of energy. As we choose colors and draw from our life experiences we can all appreciate the range of our expressive powers. All these feelings or events can translate naturally into color, and in turn, the elemental quality of the color chord can influence drawing. We don't have to learn this elemental language. It is inherent in us.

The serious study of colors is an excellent means to the cultivation of human beings, for it leads to a perception of inner necessities.

Johannes Itten

An undeserved parking ticket brings out the element of fire in Pat Kriegler's paper selection (above) and drawing (right).

the four elements in color

Underlying all the changing aspects of color are the basic qualities of the four elements. The same archetypes of earth, air, fire, and water that spontaneously emerge from the memory of a life event can be intentionally chosen.

Collage stands somewhere between drawing, painting, and sculpture, having influence on them all.
Edward Hill, *The Language of Drawing*

EXPERIMENT: The Four Elements in Color
To begin, close your eyes, and notice how you feel in this moment. Then name each of the four elements, taking the time to notice how each one is influencing your state of being. Then select colored papers for each of the four elements, one at a time, letting the sensations you experienced when you named each element guide your choices.

In a group, our color choices reveal an expressive language we all share, and most elements are easily identifiable. The cooler colors usually chosen for water often contrast with the sharper reds and oranges of fire, and the lighter colors of air contrast with the often darker, muted colors of earth. Noticing these common color choices, we can appreciate our universal fluency with the language of color, an understanding not dependent on special gifts or training.

But as we look more closely, individual distinctions become clear—we all speak an elemental language of color, but there are an infinite variety of dialects. Some people select colors that resonate with the browns and grays of earth; others prefer the bright intensity associated with fire, or the shimmer of air and water. In distinguishing our individual preferences, we become more familiar with our unique expressive powers and the roots of personal style, as we can see with the universal agreements and individual differences between the two creators below.

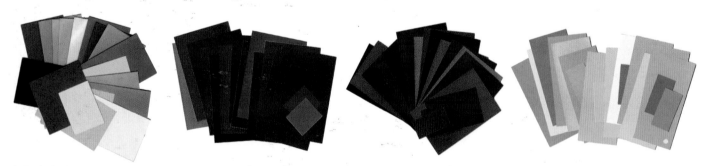

Leila Joslyn's colored paper choices (above) have a lighter feeling with more variation of light and dark within each element—(left to right) *Water*, *Fire*, *Earth*, and *Air*. The orientation of the papers seems to create whirling movements characteristic of water and air, even in her earth element. Ayumi Kie Weissbuch's colored paper choices (below) are very distinct from one another, from the vivid blues of *Water* (left), to the rich diversity of *Earth* (second from right), to the expansive delicacy of *Air* (right), to the intensity of *Fire* (second from left)—reflecting the elemental power of Hawaii, her original home.

If done on an ongoing basis, the experiment of choosing colors based on daily events and feelings can become a personal color journal. The collages shown here were part of a color journal that artist Beatrice Darwin kept every day for a month. Each day brought a new event, sometimes visual, sometimes more emotional, revealing the often unrecorded sensations that weave the fabric of everyday life. Her descriptive titles bring an added dimension of meaning, but the colors and shapes carry the real message.

In creating these collages, Beatrice used papers gathered from commercial sources and from everyday life. She cut or tore them, according to the emotional impact of each experience. Beatrice has worked in collage for many years, expressing not only daily events but times of dramatic change as well.

EXPERIMENT: Approaching Collage

Try this for yourself: Get papers from all sources, arrange them according to what you feel is right, and glue them when the arrangement feels complete. Tearing and pasting the paper adds the dimension of shape and texture and can bring a momentary arrangement closer to a completed work.

Beatrice Darwin, *Frost by the Road This Morning*, paper collage (top); *John Mack—Oboe, and Hindemith*, paper collage (above)

Each day brings a new event, revealing the sensations that weave the fabric of everyday life.

Beatrice Darwin, *After M. R. I. Scan*, paper collage

Color can bring us into acceptance and celebration of life. Color can express our deepest fear. Through color and form, Beatrice has declared her appreciation and celebration of life in the face of life-threatening conditions, using the spontaneity and power inherent in the medium of collage.

the expressive freedom of collage

When we choose colored papers and arrange them on a sheet of paper we are engaged in the process of collage, a powerful medium that can bring together unexpected elements and allow the spontaneity of random choices. Collage has been an important doorway for contemporary artists. To bring a sense of tactile reality to their work, Braque and Picasso glued newspapers and objects to their Cubist paintings, challenging conventions of oil painting. Unable to paint in his last years, Matisse culminated a lifetime of celebrating color by cutting large shapes out of painted paper and arranging them on walls. The collages of these modern masters have had an important influence on contemporary art, bringing back a more primal form of creative expression, extending art to include the forms and objects we find in our daily living.

Kurt Schwitters, *Merzbild mit Regenbogen*, montage/mixed media, 61⅝ × 47¾ × 10½ in., 1920/1939. Yale University Art Gallery, Charles B. Benenson, B.A. 1933, Collection.

Kurt Schwitters evolved a fully developed style in collage, opening the way to present-day installation and performance art. This work is a prime example of Itten's contrast of saturation, playing small piece of rainbow against the subtle neutrals.

I could not, in fact, see any reason why one should not use the old tickets, driftwood, cloakroom-numbers, wires and parts of wheels, buttons and old lumber out of junkrooms and rubbish heaps as materials for paintings as well as the colors that were produced in factories.

Kurt Schwitters

Painted houses, Buenos Aires, detail

The process of choosing colors brings us back to a primal impulse to give color and order to life.

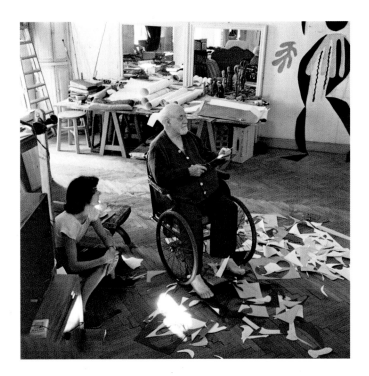

Henri Matisse at work, making paper cutouts, 1953, photo, Helene Adent, Musee National d Art Moderne, Centre Georges Pompidou (above right); Henri Matisse (1869–1954) *The Snail*, gouache on cut-and-pasted paper, 287 × 288 cm, 1953. Photo credit: Tate, London. © 2008 Succession H. Matisse, Paris / Artists Rights Society (ARS), New York (right).

Collage, the most artistically sophisticated medium of Matisse's later years, is related to our basic color selection process.

I have attained a form filtered to its essentials.

Henri Matisse

I first of all drew the snail from nature, holding it. I became aware of an unrolling. I found an image in my mind, purified of the shell.

Henri Matisse

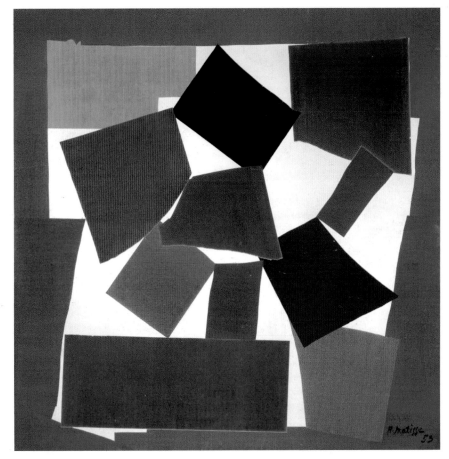

color chords on checkerboard squares

Another method that allows you to focus on color expression involves a format of checkerboard squares. This method, inspired by Johannes Itten in *The Art of Color*, is an excellent way to explore any of the colored drawing media (crayons, pastels, etc.) or any kind of paint. Like the squares of colored paper, the checkerboard squares create a neutral structure, unencumbered by representational images and shapes, in which personal color harmonies can be expressed.

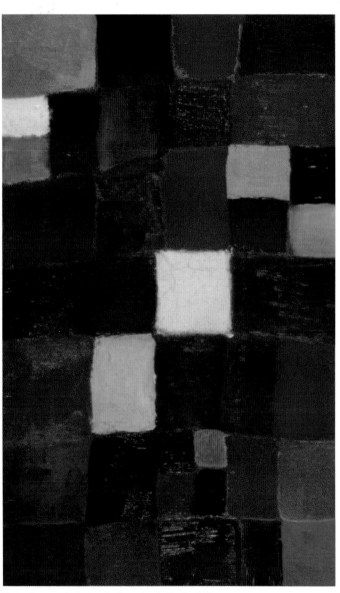

Regina Krausse, checkerboard color study, oil, 12 × 20, 1997
This extended study contrasts earth tones with intense colors.

EXPERIMENT: Color Chords on Squares

Begin this experiment by drawing a grid with a pencil or light-colored crayon, measured and drawn with a ruler, or more loosely defined, drawn freehand. This grid can include sixteen, twenty-five, or more one-inch or half-inch squares, depending on the size of the paper, which can be any color.

After looking at the empty grid for a while, choose a crayon, pastel or paint, and then sense where it wants to go, trusting your impulse. When you fill in the first color in one square of the grid, let this first color suggest the next. Continue to fill the grid with different colors until the composition seems complete. The checkerboard can be built up thickly, with many revisions, or it can be left with parts of the background still showing.

As a variation to this experiment, you can begin by placing square patches of crayon, pastel, or paint on an empty page, allowing the areas of color to create their own kind of grid, almost like quilting squares. The individual variations can be fascinating, but it is important to maintain a sense of geometric simplicity, as this creates a container for our powerful yet often unexpressed sense of color.

Because color is so often associated with symbolic imagery and representation, it can be a revelation to discover the variety and range of our expressive powers when we give it our full attention. Itten's use of the checkerboard was influenced by the compelling harmonies of his colleague Paul Klee, whose "magic squares" (see page 109) explore the heart of color.

the language of color:
a bridge between worlds

The color chords can create an important bridge between daily life and art—an opportunity to explore the thin line between the craft disciplines and the forms of fine art. The anonymous artist who combined resonant rusts, blacks, grays, and purples in a quilt for functional use (below), and the subtle checkerboard painting in browns and grays (opposite) paralleling Paul Klee, were both inspired by the muted colors of earth and both valued color for its own sake. Creative invention flourishes when color fills us with such delight or fascination that we follow wherever it leads, regardless of plans or the intended use of the object we are creating.

The passion for color is a primal source of creative expression, regardless of media or time spent on a work. The traditions of craft and painting can give the original impulse a depth, completeness, and a place in the world, but it is the elemental essence expressed through color that gives art its soul and creative center.

Bill Littlewood, checkerboard, oil crayon
Primary colors are sharply defined with parts of the background still showing.

Barbara Lawrence, *Earth*, Color-aid paper selection
This color chord, chosen in a few minutes to express the element of earth, echoes the muted tones of the quilt (left) and Regina's checkerboard study (opposite).

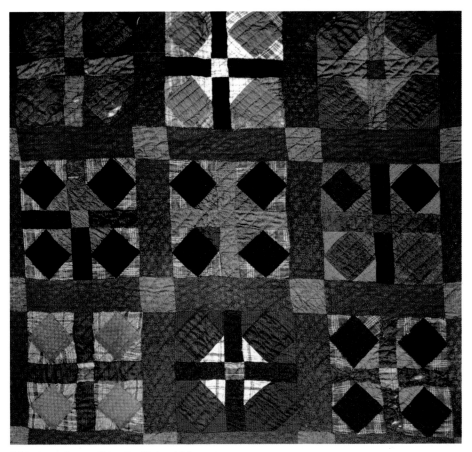

Artist unknown, brown quilt from New Mexico, detail
The variety of subtle harmonies in this quilt suggests a love of color for its own sake, far beyond its functional use.

Color Chords: A Bridge to Painting

The energetic quality of spontaneous color chords can be the inspiration for a drawing or painting, which can be developed in any medium, in any style. Free from the pressure to create a product, we can use the immediacy of the paper swatches or checkerboard squares to clarify the felt sense of our experience. The color harmonies that are revealed can be a bridge between the intuitive, elemental world and the techniques and requirements of specific media.

Color as a Healing Language

The color chords also bridge the world of art to the world of healing and spiritual awareness. Making these chords is a form of meditation in which we can experience the mysterious forces of the elemental world. In the simple act of placing one color next to another, we are both expressing and balancing these forces. This balancing is apparent in the series of color chords by Aenea Keyes (below) chosen in a healing process. The first-choice colors of fire and earth, expressing anger, gave way to the quiet poignancy of her second-choice neutral grays. A reassuring chord of purple and blue, her third choice and resolution, followed these grays, evoking the luminous element of water. The instinctive movement of these elemental qualities eventually led to a release of tension and anxiety.

Although the color chords in this series express very personal feelings, they also reflect elemental archetypes used universally by other artists. Aenea's more assertive red and black squares are reflected in Lynelle's *Persimmon Landscape* (opposite top). The cooler tones of her other color chords are echoed in my landscape, *Tomales Bay* (opposite bottom).

A full spectrum of human emotion can be seen in this personal healing process by violinist Aenea Keyes. The paper colors evolve like movements in a sonata—the assertive red and black followed by subtle grays, and ending with a peaceful blue and purple harmony.

Lynelle, pastel on paper, 12 × 12 in. (above); *Persimmon Landscape*, acrylic on canvas, 54 × 48 in., 1986 (right)

A checkerboard harmony of orange and red against black finds a fuller expression in the large painting, *Persimmon Landscape*.

Connie Smith Siegel, Color-aid paper (above); *Tomales Bay*, pastel, 19 × 23 in. (right)

A close harmony of blues is the foundation of an ocean landscape.

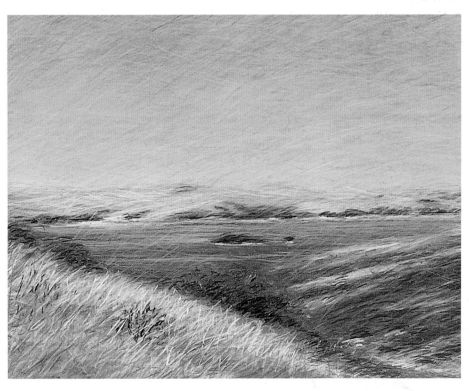

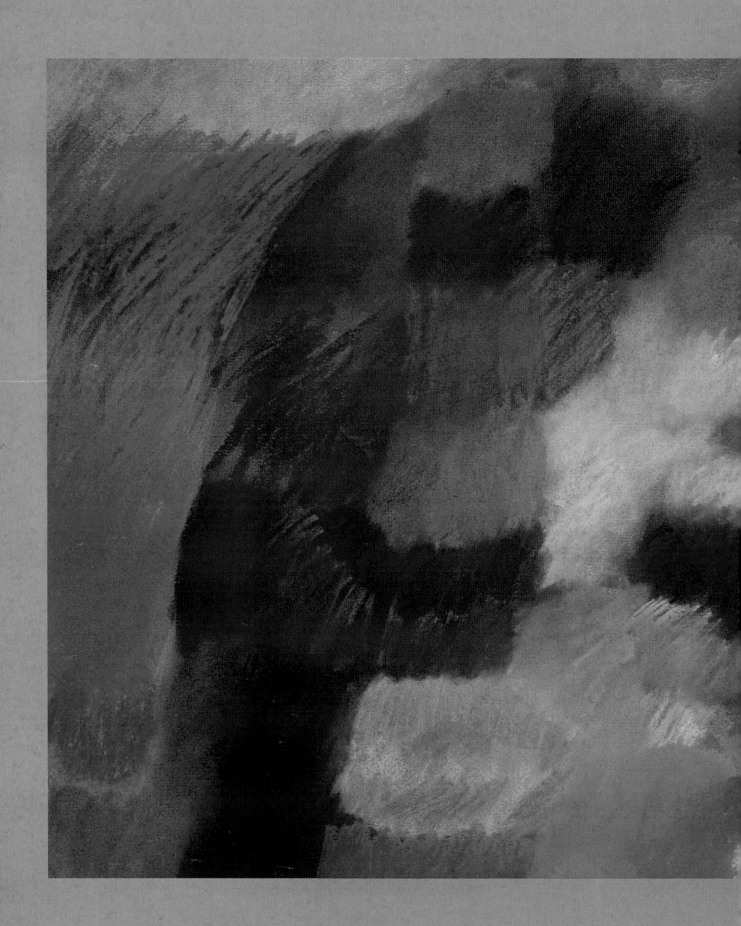

CHAPTER THREE

the union of drawing and color

In this chapter we will expand the expressive range of your intuitive choices in color with the rhythms and personal touch inherent in drawing. Drawing with color from our color chords will lead us into spirited improvisations, bringing our intuitive choices to life. The elemental qualities of earth, air, fire, and water can be expressed in their full variety and richness, enlarging your visual vocabulary, and evoking inner sensations. The principles of abstract composition in drawing and painting will be demystified as you discover your innate capacity to express the rhythms and distinctive shapes and colors of each element, as well as your life events.

Jan Gross, *Red Sphere* (detail), pastel, 20 × 30 in.
The pulsing red and blue color chord finds full expression with the personal touch and nuances of pastel.

drawing and color combined

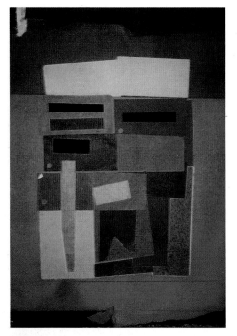

Jan Gross, improvisational pastel, 20 × 30 in.
Jan Gross's colored paper selection (top) influences her pastel painting (bottom).

In the last chapter we focused on the expressive qualities of color—an elemental language we all possess. We explored ways in which color can reveal our personal color harmonies when separated from drawing and representation. But you may be missing the personal touch and sense of movement inherent in drawing. When we bring drawing and color together, we can experience the full range of the visual language and discover creative media that can match our natural tendencies. Although the interaction between drawing and color is as large as the visual field itself, here are some ways of combining the two that can grow naturally out of the work we have covered so far.

EXPERIMENT: Color as a Source for Drawing

To explore the influence of color on drawing, begin with the process of choosing colored papers from a pile, selecting at random any combination, any number of colors. After putting these colors on a sheet of paper, prepare another sheet of paper for drawing, and select colored drawing media (see pages 166–167.)

To let your chosen color chord set the tone before drawing, first take some time simply to see it. See the color chord as if listening, letting it resonate through your whole body, noticing any sensations that might wake up as you see the colors together. Is there a quality of sound in the colors that could influence and inspire you as music might? Can you also notice a sense of movement, a basic rhythm pulsing through the colors? You might even make a sound yourself, or move in response to what you are feeling under the influence of the colors.

As you draw, allow the feeling qualities of the colors to affect your touch on the paper, the rhythm of the stroke. The energetic presence of your color chord can bring forth a wealth of shapes and images that express your inner sensations in this moment.

EXPERIMENT: Expressing Our Lives

After picking the color chords at random, it can be interesting to intentionally suggest a theme. Invite a memory or current situation from your life into your consciousness. Notice what colors accompany this feeling or event, and pick these colors from a pile of colored papers. Any occurrence, no matter how intense or ordinary, can become the source of a color combination.

As you begin to draw, allow these colors to influence the drawing. Let it evolve in any way, beginning with eyes closed if this helps the flow of the lines and shapes. Notice the way the drama of a life-threatening event (*Surgery*, opposite top) and the reassuring memory of a beautiful place (*Clouds and Beach*, opposite bottom) expanded Jan Gross's expressive range.

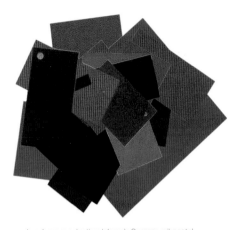

Jan Gross, colored paper selection (above); *Surgery*, oil pastel, 18 × 24 in., 1994 (right)

An emotional memory of the open-heart surgery of a loved one is expressed in a color selection (above) and then in a drawing (right). The drawing gave a definite form and movement to the strong emotion.

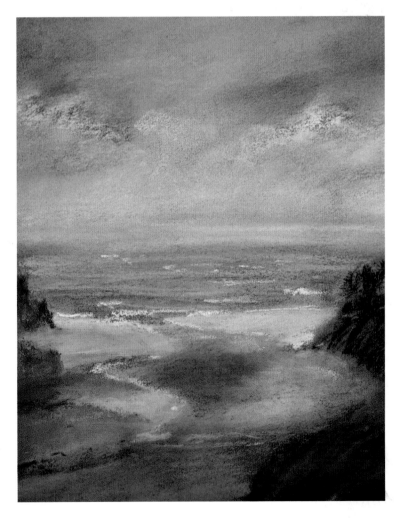

Jan Gross, colored paper selection (above left); improvisational drawing, pastel (above right); *Clouds and Beach*, pastel, 18 × 24, 1998 (right)

The memory of beach and sky inspired Jan Gross's color chord and pastel improvisation. Later, the emotional serenity of this abstract work inspired her landscape, painted on location.

The abstraction is often the most definite form for the intangible thing in myself that I can only clarify in paint.
Georgia O'Keeffe

EXPERIMENT: A Series of Colors and Drawings

After choosing a color chord and drawing from it, take the time to feel them inside. Then pick another set of colors and draw from them, noticing any changes. After seeing the first two drawings, choose a third set of colors and draw again. As you see all three drawings, notice how one elemental quality spontaneously relates to another. The changes could be dramatic, or more subtle, as in Katherine Callaway's drawings (opposite), or include visual observations from your life.

Pat Kriegler, *The Bird of Death*, pastel, 18 × 24 in. (top left); *Spring Blossoms*, pastel, 18 × 24 in. (bottom left); *Rock and Roses*, pastel, 24 × 18 in. (above)

Pat saw a large blue jay stalk a smaller bird—a reminder of death (top left). This dark force was balanced by the life in the roses (bottom left). Pat integrated the roses with the powerful curves of the bird, echoed in the rock formation (above)—large enough to hold both life and death.

Katherine Callaway, spontaneous oil pastel drawing (right)

The emotional drama of the bright colors (above) led to an explosion of lines and shapes in the first drawing of this series (right).

Katherine Callaway, second spontaneous drawing (right)

The grays and blacks of the second color choice (above) instinctively balance and ground the first color choice (top). These darker tones spontaneously generate a drawing of a tree rising from dark shapes (right).

Katherine Callaway, *Landscape*, oil pastel, 12 × 15 in. (right)

The opposite qualities of the first two color choices are reconciled in this subtler work (right), created at a later time. The muted color chord (above) leads to a more developed landscape of interlocking strokes.

experiencing the elements

Pat Kriegler, element of air (top); Patsy Maloney, the element of air (center); Mai Aquilar, the element of air (bottom)

Each version of air is different, yet they share common qualities.

No matter what the subject matter of our work, underlying everything are the elements of air, earth, fire, and water. When these elements are expressed in both drawing and color, we can more fully experience the universal power of these visual archetypes as well as each individual interpretation.

The Element of Air

To appreciate the inner source of the elemental archetypes, we will take the time to experience the feeling qualities of the element of air.

EXPERIMENT: The Element of Air

Close your eyes, noticing your state of being in this moment. As you name the element of air to yourself, do you notice any inner changes? What are the sensations that come with air? With your eyes closed, what sense do you have of the air within you and around you? You may experience a different quality of breathing, sense of weight, or inner space.

As you experience the element of air through all your senses, do one or more colors come to you? After a time, pick these colors from the pile, trusting whatever seems right. When you have chosen the colors, stop to contemplate them, noticing how they make you feel. Out of this inner feeling, put the crayon to paper, letting a drawing evolve. Let yourself be carried on a creative adventure, with no expectations, no demands, as you allow the element of air to express itself through lines, shapes, and colors.

Although each person has his or her own unique experiences, when we see the drawings and colors of air from different people, it is clear that each has been touched by a similar quality. Often we can see this in the airy tints—whites, light pink, cream, and blue-greens—which seem to reach beyond matter into the sky. There is often lightness to the drawings, with spaces left in between, a circular movement that fills the page, and a sense of particles dispersed throughout. Although there are always exceptions and individual interpretations, enough people produce these visual archetypes to demonstrate the universality of the qualities of air.

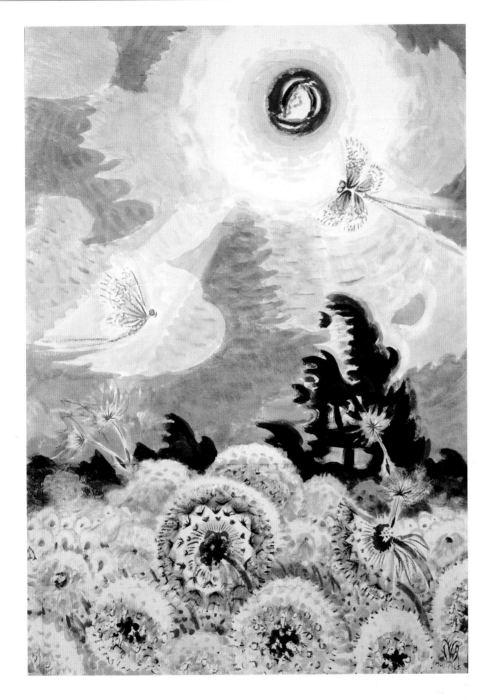

The movement of air has found a full expression in Burchfield's painting, from the rhythmic circles of the dandelions to the bending tree to the flying clouds and whirling moon.

Landscape . . . probes into the secrets of life, nature, and the world of the spirit.

Charles Burchfield

Pat Kriegler experiences the element of earth in her own body—in her bones.

Think of our life in nature . . . rocks, trees, wind on our cheeks! The solid earth! The actual world!

Marsden Hartley

The Element of Earth

Earth has very distinctive qualities. It can evoke strong emotions and inspire very distinctive qualities when experienced from the inside.

EXPERIMENT: The Element of Earth

As you did for the element of air experiment, close your eyes and notice any inner sensations you feel when you experience earth. Then choose colored papers that resonate with those feelings. When you draw from the colors, notice how the forms and rhythms, and even the manner of working, change with the element of earth. You can experience the elements of water and fire in this same manner.

Although each of our responses is unique, there are many common experiences and characteristic colors, rhythms, and shapes for the element of earth that anyone can recognize, no matter what level of experience in art.

When focusing on the element of earth, many feel a sense of solidity and weight, an awareness of legs and feet meeting the ground. These sensations are often expressed by the nameless varieties of browns, blacks, ochres, beiges, olive-greens, and khaki colors associated with particular places. These colors can form definite shapes, with a strong contrast between light and dark.

Regina Krausse, the element of earth, pastel (above); Vivienne Moynihan, the element of earth, oil pastel (top right); Kristina Muhic Arroyo, the element of earth, oil pastel (bottom right)

From the rich depths, earth generates the many forms of life (above and top right). Kristina's earth is animated by the archetypal movement of water (bottom right).

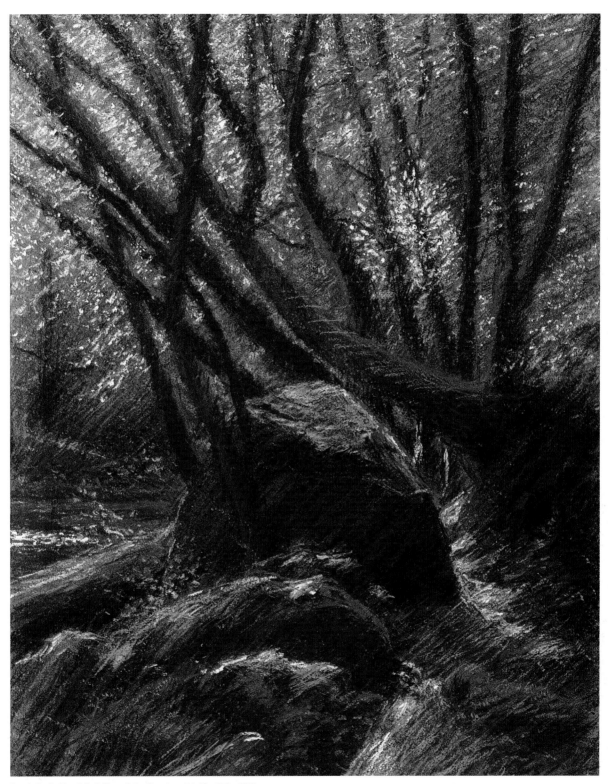

Connie Smith Siegel, *Path Through the Forest*, pastel, 30 × 22 in., 2007

Trees and moss grow on a rocky path along a stream, leading into the heart of a dense forest, an earthy realm only penetrated by late afternoon light.

Margaret Linsey, the element of water, pastel

The Element of Water

The element of water can be felt as a sense of fluidity, of continuous wavelike movement, often calming and circular. It can be expressed in greens, blues, and purples, sometimes in deep tones closer to earth, sometimes lighter, closer to air (left). Although each expression is unique, the archetypal forms of water—circle and wave—remain constant in these individual variations. Notice the famous archetypal wave of the nineteenth-century Japanese master Hokusai unconsciously echoed in a student water improvisation (opposite top). Experiment with the element of water as you did with air and earth, noticing inner sensations, colors, and drawings that spontaneously come.

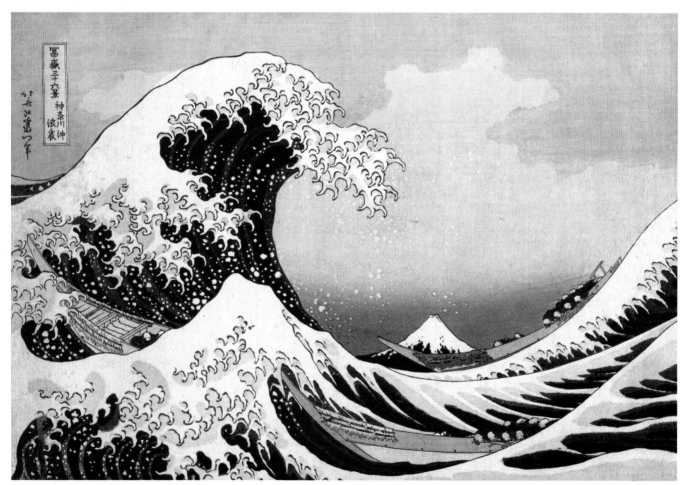

Katsushika Hokusai (1760–1849), *The Great Wave at Kanagawa* (from a Series of Thirty-six View of Mount Fuji). Ca.1830–1832. Japan Edo period. Polychrome woodblock print; ink and color on paper, 10 1/8 × 14 15/16 in. (25.7 × 37.9 cm). Published by Eiudo. H. O. Havemeyer Collection, Bequest of Mr. H. O. Havemeyer, 1929 (JP1847). © The Metropolitan Museum of Art, New York, NY, USA

The tactile detail of Hokusai's well-known wave (above) is combined with the archetypal power of the abstract forms. These same forms occur spontaneously in student improvisations on water, from Margaret Lindsey's airy version (top) to the two more definite versions on the opposite page.

The fierce power of Kathleen Watson's element of water resembles the wave of Hokusai.

The laws of the stars descend and through the mediating elements of air and water impress themselves on the earth.

Theodor Schwenk,
The Sensitive Chaos

The wavelike forms of water are clearly defined by Kristina Arroyo Muhic.

The Element of Fire

After a pause from the other elements, explore the element of fire, noticing any inner sensations, colors, and drawings that spontaneously come as you focus on this element.

The element of fire can be very enlivening, and the reds, oranges, yellows, and blues that often appear are typically applied with vigor and assertiveness. Fire mobilizes energy, and its elemental power moving through a group creates a wealth of unexpected forms and individual variations. The rising movements and intensity of color in many of the examples shown here can also be seen in my landscape *November Vines*. We will explore these qualities later in the Itten contrast of hue (see pages 62–67).

Fire inspires Linda Larsen's definite, bold strokes.

Fire of all things is the judge and ravisher.
Heraclitus

Connie Smith Siegel, *Sonoma Vines November* (detail), pastel, 18 × 30
These grapevines in November turn fiery red, each tree rising defiantly against the distant hills.

Regina Krausse's assertive strokes, inspired by fire, create a shape.

For Nancy Niles, fire creates its own light source.

Kristina Arroyo Muhic uses archetypal forms of fire—jagged shapes, rising upward.

Emilio Lanier, *Fire*, oil pastel, 1998

The Four Elements: Two Interpretations

As much as we share a language of elemental archetypes, we each speak that language in different ways. Most people are drawn to some elements over others. Some people, such as Emilio Lanier (left, below, and opposite), never lose the sense of bright colors and strong value contrast, even when expressing air and water. Others, such as Audrey Wallace Taylor (see pages 52–53), choose more complex combinations that often include the subtler tones. The differences among people are especially clear when all four elements are present.

In *The Art of Color*, Johannes Itten describes these distinctive tendencies as a "color aura," which each person is born with and which is modified by the events in his or her life. As we choose colored papers and draw from inner sensation, we cannot help expressing who we are.

But nothing is ever totally constant. Even though each of us has a home base in one or more of the elements, we move from this base in unpredictable ways, and we can always be surprised by the forms we produce. In spite of our reasonable assumptions or expectations, our nature has its own agenda, which moves us inexorably as the magnetic forces under the earth, the great patterns of wind and rain, and the mysterious movements of river, ocean, moon, and stars. As creative expression gives color and form to the movement of our own natural forces, we come closer to our own mystery.

Emilio Lanier, *Water*, oil pastel, 1998

Emilio Lanier, *Air*, oil pastel, 1998

Emilio Lanier, *Earth*, oil pastel, 1998

Emilo Lanier, *Trees*, oil pastel, 18 × 24 in.

The strong shapes and value contrasts in Emilio's elements emphasize the qualities of earth and fire.

Audrey Wallace-Taylor, *Fire*, oil pastel, 15 × 15 in.

Audrey Wallace-Taylor, *Water*, oil pastel, 15 × 15 in.

Audrey Wallace-Taylor, *Air*, oil pastel, 15 × 15 in.

Audrey Wallace-Taylor, *Earth*, oil pastel, 15 × 15 in.

The subtle transitions in all four of Audrey's elements emphasize the qualities air and water. The same forms and colors appear in her landscape, in which all four elements are combined.

Audrey Wallace Taylor, *Needle Rock*, watercolor, 30¼ × 22½ in., 1999

*Color is the place where our spirits
and the universe meet.*

Paul Cezanne

Connie Smith Siegel, paper selection (above); *October
Willow and Stream, Bishop Canyon*, pastel, 1997 (right)
The fiery light of October willows combines
with water and earth (right). The color chord
(above) brings back the original spirit of the
painting.

Connie Smith Siegel, oil crayon
The fiery light of autumn leaves, growing
from a dark source.

Exploring Elements in Nature:
The Elements Combined

Whether chosen before you start painting or later while painting, the expression of
drawing and color in its primal abstract form brings us home to our essential core. The
color chord and my spontaneous drawings (below left) helped me complete *October
Willows*, which I started on location in the eastern Sierras. Choosing the colors at home
and drawing from movement reminded me of the original excitement I felt there.

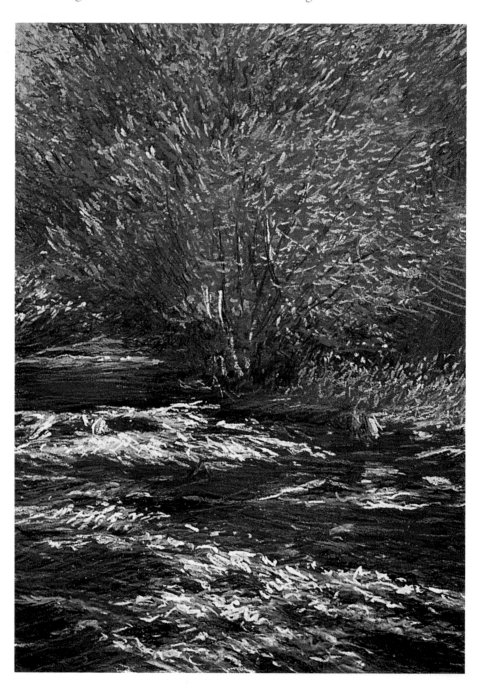

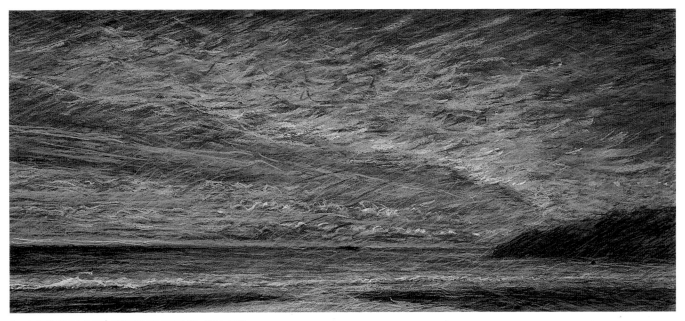

Connie Smith Siegel, *Sunset at Muir Beach*, pastel, 30 × 60 in., 1999

The element of fire in the sunset is integrated with air, water, and a suggestion of earth.

Connie Smith Siegel, pastel drawing

Colors chosen for fire later find expression in a sunset.

Connie Smith Siegel, *San Geronimo Valley, October*, pastel, 19 × 25 in., 1999

The element of earth predominates, but light/air is important, as well.

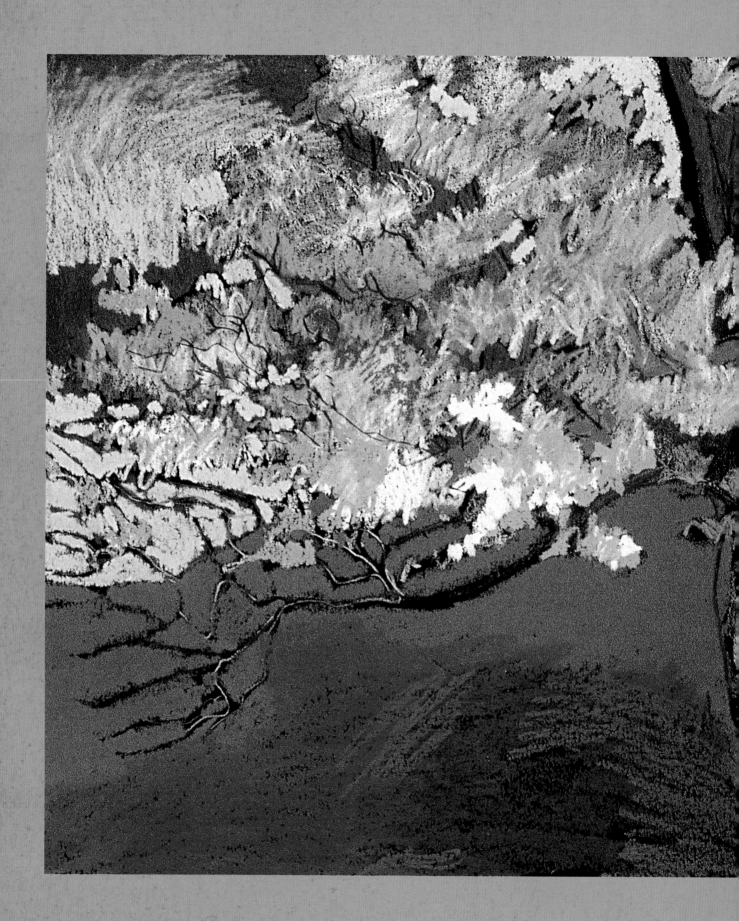

expressive color: the world of light

In the previous chapters we worked with the variety and richness of subjective color chords, chosen with colored papers, and drawn with pastels. We explored the inner effects of these chords and their relationship to the elemental qualities of earth, air, fire, and water. In the next chapters we will use the theories of Johannes Itten in *The Art of Color* to experience these elemental qualities more deeply, expanding into other media and working from images. As you identify your own natural tendencies through his system of color contrasts, you can find your place in the family of other artists and the tradition of painting. We will first explore the intense color ranges—the primary hues, the vibrancy of complements, and the shimmery radiance of light.

Jackie Kirk, *Plum Tree*, colored pencil, 12 x 17 in.
The complements pink and green glow against black.

Even before my studies with meditation and sensory awareness, Itten's color contrasts provided my students, colleagues, and me with an opportunity for a shared experience of visual meditation and personal discovery. Itten's research in color opened a magical world for me, from the his students "subjective" color chords (below) to his system of seven color contrasts, which provides a working structure to explore individual expressions. As we uncovered the source of certain visual effects, we understood more deeply the development of personal style. As I realized how closely his color contrasts echoed elemental emotional states, it was clear that this study not only expanded visual effectiveness but also brought an expansion of consciousness as well.

Itten's contrasts are based on life in its fullest expression, on the dynamic action of primal polarities such as warm/cool, light/dark, and bright/dull. Like music keys (C major, D minor), the distinctive qualities of each contrast can strike emotional chords within us. Because these qualities are based on the elemental archetypes of earth, air, fire, and water, they invite us to experience all the forces of the natural world.

By giving each elemental quality a name and a place in a logical system, you not only explore your own nature more deeply, but you also create a bridge from your personal exploration to the larger community of artists, past and present. We can experience the courageous discoveries of Matisse and Kandinsky, the shimmering world of the French Impressionists, the dark power of Rembrandt, or the subtle nuances of Whistler and Turner. By entering the energetic source of their expressive magic, we can claim it for ourselves in our artwork, and if it fits, sustain it over time.

As you work within the structure of color contrasts it is important to keep a spirit of adventure, seeing each contrast as an opportunity for discovery and not as a demand for perfection. If you find yourself judging your work, return to the earlier experiments in color. As you choose color and draw from your inner sensation, you come home to your original essence. And when you are home, you can do nothing wrong.

Colors are the children of light and light is their mother.

Johannes Itten, *The Art of Color*

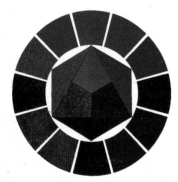

12-hue Color Circle, from Johannes Itten, *The Art of Color*, © 1961 Otto Maier Verlog Ravensburg. Reprinted with permission of John Wiley & Sons, Inc.

Portraits of Itten's students and their subjective color chords, from Johannes Itten, *The Art of Color*, © 1961 Otto Maier Verlog Ravensburg. Reprinted with permission of John Wiley & Sons, Inc.

Itten's twelve-hue color wheel, reflecting the full spectrum, becomes differentiated by each person's unique color harmonies.

THE SEVEN COLOR CONTRASTS OF JOHANNES ITTEN

This outline of Itten's seven color contrasts describes each contrast, but you will know the real meaning of these terms only when you actually experience each one through drawing and color media.

CONTRAST OF HUE embodies passionate intensity (which is inherent in the element of fire). Its colors come from the full spectrum of undiluted colors we see when sunlight is refracted in a rainbow, or by a prism. It includes all of the colors on the color wheel, especially the three primaries—red, yellow, and blue—which vibrate strongly against each other and can be seen in the work of Matisse, Kandinsky, and Nolde.

The dynamic action of the **CONTRAST OF COMPLEMENTS** is more focused, coming from the interaction between complementary pairs—colors opposite each other on the color wheel. They balance each other in the eye as well, each making the other brighter. This action underlies the remaining six Itten contrasts, and it can range from exceedingly brilliant to very subtle.

The action of *dramatic* complements is on the brilliant side, combining the full intensity of one or more complementary pairs with the full range of light and dark. It is focused and purposeful in its effects, as we can see in the paintings of van Gogh.

CONTRAST OF WARM AND COOL, on the other hand, has very little value contrast, as it expresses the immateriality, the "shimmery" effect, of air, light, and water. At its core is a highly vibrant interaction between the complements blue-green and red-orange, accompanied by purple. We see it in stained glass windows and in Impressionist paintings by Monet, Pissaro, and Bonnard.

CONTRAST OF LIGHT AND DARK expresses the tangible substance of earth through the polarity of light and dark, black and white, and all the grays in between. It is prominent in the work of sixteenth-to-nineteenth-century masters like Rembrandt, Caravaggio, and Goya and modern masters like Edward Hopper and Franz Kline.

CONTRAST OF SATURATION resonates with the sonorous tones of earth, playing small amounts of bright color against larger amounts of dull or neutral color. Depending on light and dark for its structure, it can be seen in the old masters and in such modern painters as Andrew Wyeth, Georges Braque, and Giorgio Morandi.

SIMULTANEOUS CONTRAST is defined by the balancing principle in the eye that turns a small amount of neutral color simultaneously into the complement of its larger neighboring color. This elusive contrast balances the elements of air, earth, and water. Its luminous subtlety is seen in Turner, Whistler, and the American Tonalists.

CONTRAST OF EXTENSION is not associated with any one element, but it can intensify any of the other contrasts by playing a small amount of one color against large amounts of another color or neutrals.

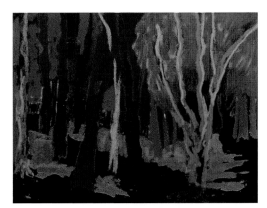

Sandy White, *Walking in the Woods 1*, pastel, 2006
The fiery intensity of contrast of hue.

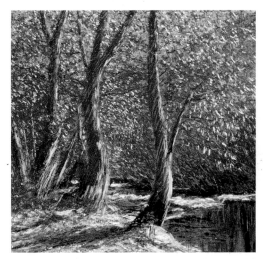

Connie Smith Siegel, *October Aspens, Lundy Canyon*, pastel, 19 × 19.5 in, 1999
The shimmery contrast of warm and cool.

Virginia Huega, *Tree in Devil's Gulch*, charcoal, 18 × 24 in
Earth power in contrast of saturation/value.

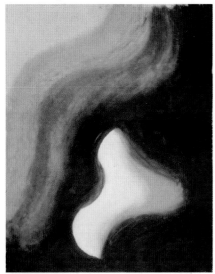

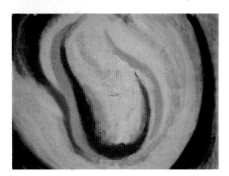

David Miller, three improvisations, oil crayon

David Miller expresses the fiery presto movement: contrast of hue (top); the somber largo movement: contrast of saturation/value (center); and the gentle rondo movement: simultaneous contrast, warm-cool (bottom).

The study of Itten's seven contrasts will take us even more deeply into the elemental archetypes. We will move into a kind of discipline inherent in all the arts, especially the performing arts. Like actors or opera singers preparing for different roles, we will consciously intensify and sustain elemental/emotional qualities that may be different than our momentary feeling states. This creative discipline requires us to reach an emotional edge yet not go beyond it.

This discipline was evident as I listened to the pianist Claudio Arrau's concert of Beethoven sonatas. During a particularly poignant largo movement in the Beethoven Sonata in D (Opus 10, No. 3), he bent over the keys, seemingly close to tears. And yet minutes later he was tripping over the keys with the lilting quality of the allegro movement. The program notes, written by Arrau himself, eloquently describe the different emotional qualities contained in this sonata.

EXPERIMENT: Evocations from a Sonata

Without even hearing the music, when you read Arrau's descriptions of three movements in the sonata below, what sensations, colors and/or movements are evoked by each?

> *The presto is one of the most brilliant opening movements in all the thirty-two sonatas. It carries a defiant proclamation of confidence and élan. The pulse of life is running joyously.*
>
> *But—how Beethoven can catch at the throat with a sudden twist of the minor key . . . the largo in D minor, by contrast, plunges to the opposite end of tragic despair.*
>
> *The rondo . . . is not a rondo in the accepted sense. Even the gentle, tentative opening poses a different idea. It is not assertive; it seems to be asking a question.*
>
> *Claudio Arrau*

Feel a quality of movement and color in each of these descriptions. Then express them, one at a time, in a visual form, either choosing colored papers and/or drawing them in color. After you have expressed them, you might be interested in the interpretations illustrated at left and opposite.

When I did this experiment with a group of students preparing to study the Itten color contrasts, I was astonished to see Itten's whole system reflected in their drawings and colors. For the most part, the vitality of fire and light (contrast of hue or warm-cool) emerged in the presto movement, the element of earth (contrast of value and/or contrast of saturation) resonated in the largo movement, and the elements of air and water (simultaneous or warm-cool contrast) appeared in the forms and colors of the tentative rondo movement. This is the wide range of elemental human emotion contained in any great symphony, play, opera, or novel.

As you move through the seven contrasts I invite you to experience each as though it were a different movement in a sonata, or character in a play or opera. Some of the contrasts may feel natural, even delightful, and others might be uncomfortable, as though you were in a foreign country, not knowing the language and out of your element. The primary purpose is to find your own creative voice, reinforcing what you have always loved and reclaiming the expressive powers you may have forgotten or were afraid to exercise.

In claiming your powers, the Itten color chart below will be an important resource, as it contains the visual vocabulary for all the contrasts. It combines the vibrant hues of the color wheel with the light and dark clarity of the value scale. Its meaning will be even more clear as we explore the color contrasts in more depth.

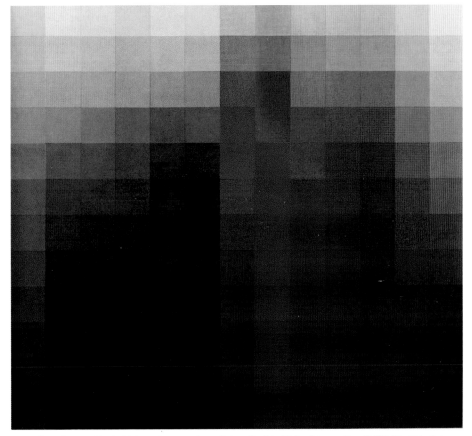

12-hue Color Circle combined with the twelve-tone value scale from *The Art of Color*, Johannes Itten. © 1961 Otto Maier Verlag Ravensburg, reprinted with permission of John Wiley & Sons, Inc.

The visual vocabulary for the elemental archetypes of the seven contrasts combines the light and dark value scale with the twelve-hue color wheel.

Barbara Dose, three color selections, paper

Barbara Dose expresses the fiery presto movement: contrast of hue (top); the somber largo movement: contrast of saturation/value (center); and the gentle rondo movement: simultaneous contrast, warm-cool (bottom).

contrast of hue: the element of fire

Rosie Echelmeir, improvisation, oil crayon (top); David Miller, improvisation, oil crayon (bottom)

Salsa music inspires primary colors.

When we express the element of fire, hear the sounds of folk dance or salsa music, the characteristic colors of contrast of hue emerge naturally. Neutral colors and subtle transitions disappear, and the colors become pure, undiluted, and close to their original source in the rainbow.

There are at least three hues that can be identified clearly on the twelve-hue color wheel (often the primaries: red, yellow, and blue), and they interact strongly with each other. All these intense qualities match Itten's description of contrast of hue. In the next experiments we will go more deeply into these characteristic colors.

EXPERIMENT: Experiencing Each Color

As a preparation for the vigorous interaction of colors inherent in contrast of hue, take some time to experience the identity of each color on the color wheel by itself. Begin with your eyes closed or resting on a neutral surface. Then bring a single color—for example, yellow—into your consciousness. As you visualize a yellow, let it fill you inside. Then extend it to the space right around you, and even beyond. What sensations do you feel as your world is permeated with yellow? After a while, let yellow go. Then notice what happens when you visualize the next color on the wheel, yellow-orange. Proceed around the color wheel in the same way: orange, red-orange, red, red-violet, violet, blue-violet, blue, blue-green, green, yellow-green, and back again to yellow. Feel the energetic quality of each of these colors inside.

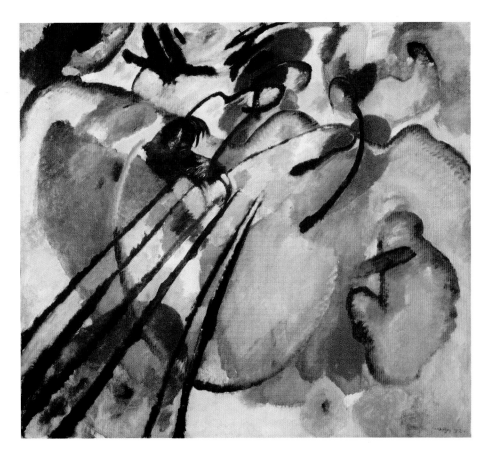

Color is the keyboard, the eyes are the hammers, the soul is the piano with many strings. The artist is the hand that plays. . . .

Wassily Kandinsky

Wassily Kandinsky, *Improvisation 26, (Rowing),* oil, 38 × 42, 1912. Städtische Galerie im Lenbachhaus, Munich. © 2008 Artists Rights Society (ARS), New York / ADAGP, Paris.

Kandinsky's brilliant improvisations reflect the colors and rhythms inherent in music. Coming from inner sensations, they pioneered nonobjective painting.

When you complete your meditation on all twelve colors, find them in your box of crayons or pastels, getting the clearest version of each you can find, matching it to the color wheel. If you are using paint, make sure you have all the colors on the wheel, using the mixing instructions in chapter 9, Media (see pages 170–173). Line up the colors alongside the paper (or canvas), like actors preparing to enter a stage.

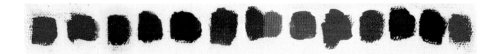

Connie Smith Siegel, paint mixtures
The twelve hues of the color wheel lined up in their color-wheel order.

EXPERIMENT: Interaction Between Colors

What would happen if these twelve colors met one another? In the color wheel each color has a proper place, like the members of a family in a family portrait. Now, let the twelve colors move out of their proper order and interact with each other in a kind of dramatic improvisation—as if they're playing a game together or getting into a conversation, or even an argument.

Before you begin, establish the borders of a square or rectangle, either the edges of your paper or smaller divisions drawn within it. As you see the space within the border, does it invite a color? When you put a color down, what color would be most vibrant against it? Let the colors themselves decide where they want to go, never losing the intensity, accepting anything that happens. The vigorous interaction among colors (especially the three primaries—red, yellow, and blue) might feel unfamiliar, even garish, but instead of restraining the effect, make it even more intense.

Alisa Klaus, contrast of hue study, oil crayon, 18 × 24
Let the colors themselves decide where they want to go, like a dance improvisation.

When the space is filled, notice how the colors have arranged themselves and the kind of forms they have created. You may be exhilarated with the process and delighted by the bright results. Or you may be uncomfortable, even embarrassed, if your work looks childlike, primitive, or too geometric.

There is no denying the strong agenda these pure colors have. They bring us back to a powerful, primal place with a heightened sense of order and balance. This sense of order often moves us toward the simplicity of geometric forms and demands that each color find its rightful place within the composition. The stronger the dynamic force of the color, the stronger is the need to balance it with another. This balancing of forces can continue even as we draw, creating powerful and original compositions that echo the modern masters such as Kandinsky and Matisse.

I always wanted my colors to work themselves out on the canvas as consistently as nature produces her own creations.
Emile Nolde

EXPERIMENT: Working with a Partner

We can experiment with the balancing principle of color even more by working with a partner. As in the previous experiment, establish the borders and then take turns with your partner filling the rectangular space with color, allowing anything to happen. Although you may have different, individual styles of working, the strong dynamic of the colors themselves generate their own, often unexpected, compositions. Responding to the unexpected with a partner can be a preparation for the next experiment, in which we find a "partner" in the world we see.

EXPERIMENT: Drawing the World with the Rainbow

Using the rainbow of colors you gathered from the last two experiments, what would happen if you were to now draw from what you are seeing in the world? To use the words of Gauguin as he instructed his student Serusier, "How do you see those trees? They're yellow, you say? Well, put on some yellow. That shadow is rather blue, paint in pure ultramarine. Those red leaves, put them on in vermilion."

In this way Gauguin instructs Serusier to ignore the subtleties of the natural scene he was painting, to use only the strongest hues, straight out of the tube. You can try this experiment with any subject—a landscape, the person next to you, or everyday objects. If you exaggerated the colors, then reverse them into complements, making the skies orange, the grass purple, etc. Your drawing or painting may or may not resemble visual reality.

The rainbow experiment above places the primary emphasis on the life of the painting, challenging the necessity for visual exactitude. We are not obligated to duplicate the subtle colors and forms of the natural world but instead can be carried into the simpler elemental rhythms and patterns that underlie all forms, bringing the chaos of the world into order.

Holly Hammond, oil pastels, 18 × 24 in.
Intense colors create their own composition (top) and are used later to draw a tree (bottom).

Ann Faught, hue study, pastel (above); *Woodacre Truck*, pastel (right)
The full spectrum of color interacts (above) and transform a neighborhood truck (right).

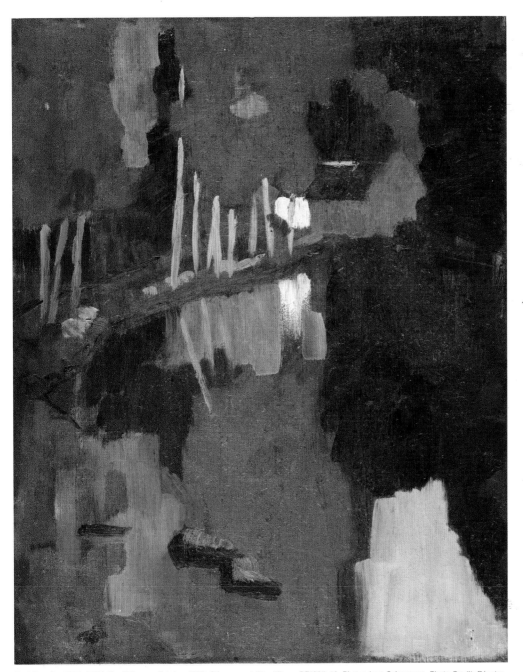

Two friends draw each other at the same time. Gail Robertson draws Gin (top), while Gin Fauvre draws Gail (bottom).

Paul Serusier (1865–1927). *The Talisman*, October 1888. Oil on wood, 21 × 27 cm. RF1985–13. Photo: Jean Schormans. Photo Credit: Réunion des Musées Nationaux / Art Resource, NY. Musee d'Orsay, Paris, France.

The result of Serusier's lesson from Gauguin is called *The Talisman*. It clearly demonstrates his epoch-making definition of the picture as "a flat surface covered with colors arranged in a certain order." This definition opened the world of painting to the abundance of color expression, which flourishes in the works of modern masters such as Kandinsky, Matisse, and Nolde.

Before it is anything else, a picture is a flat surface covered with colors arranged in a certain order.

Maurice Denis (speaking as Gauguin's student)

contrast of hue: a universal expression

Photo by David Hizer
Quetzal dancers radiate the sun energy of contrast of hue, celebrating rebirth.

As a global expression of life force, the full spectrum of contrast of hue precedes all other contrasts. We see this life force reflected in the folk art of all cultures and from all artists, regardless of age. The festivals and icons of Russia influenced the work of Chagall and Kandinsky, founders of the Blaue Reiter, a group of artists who "embodied the expression of their inner life." We can see the primal honesty of contrast of hue in the German expressionists, Nolde, Franz Marc, and Kirchner, and in the sensuous radiance of the Fauves ("wild beasts"), Matisse, Vlaminck, and Derain, who consciously set out to "purge" painting of the predominant browns and grays of the old masters.

We can see this same call to life in children as they mix paint, throwing out the browns and grays, reaching for only the pure colors. Because the primary colors are often associated with children's art, commercial advertising, or national flags, they may seem regressive, negating the subtle complexities of individual uniqueness. And yet the pure hues of our childhood are a vital part of our creative heritage. We can see this vitality in the modern master and teacher Hans Hoffman (opposite) and pop artists such as Roy Lichtenstein.

Like the sun itself, the primaries and rainbow colors bring us back to a global experience of life and the eternal promise of rebirth. Whatever discomfort we may experience from the relentless intensity of contrast of hue, we can always be regenerated by its joyous strength.

Josephine Smith, *Red Roses*, needlepoint, 8 × 10 in
A love of color is expressed in a small needlepoint.

Valentine mural, acrylic, Lagunitas School Third Grade Class, assisted by Susan Rogers, 4 × 6 ft., 1998.
Children celebrate Valentine's Day with primary colors.

André Derain (1880–1954) *The Pool of London*, oil, 26 × 39, 1906.© ARS, NY. Photo credit: Tate, London / Art Resource, NY; Tate Gallery, London, Great Britain. © 2008 Artists Rights Society (ARS), New York / ADAGP, Paris.

The night is radiant, the day is powerful, ferocious and all-conquering . . . The light throws up on all sides its vast and clamorous shout of victory.

Andre Derain

Hans Hoffman, American, 1880–1966, b. Germany. *The Golden Wall*, oil on canvas, 151 × 182 cm, 1961. Mr. and Mrs. Frank G. Logan Prize Fund, 1962.775 overall. Reproduction, The Art Institute of Chicago. Photography © The Art Institute of Chicago.

Hoffman used the dynamic action of advancing and receding color planes to express personal states of being (left). His energetic use of color continues and expands the Fauve experiments of artists such as Derain (above), whose works presaged modern abstraction.

In nature, light creates the color; in the picture color creates light.

Hans Hoffman

the dynamic action of complements

Audrey Wallace Taylor, improvisation, oil pastel

A dramatic encounter between mother and daughter is expressed in red and green.

Jean Woodard, color improvisation, oil pastel (above); Thanka, Green Tara, Nepal, collection of Tedi Dunn and Will Svabeck (right)

The interaction here between orange and blue (above) creates an energetic vibration parallel to the thanka painting (right). Underlying the symbolic content, the complements red-orange and blue-green communicate a transcendent spirit world.

Besides the action of primaries, there is another color interaction occurring in contrast of hue, which accounts for much of its vitality. Before focusing on this dynamic action, try this experiment, trusting whatever happens.

EXPERIMENT: Dramatic Improvisation

Close your eyes and notice what you feel in the moment. Then bring something intensely dramatic in your life, past or recent, to your consciousness. It could be an inner realization, personal encounter, a place, or occurrence. Notice any sensations that you feel inside, and with this, any colors. Find these colors in the color pile, and draw or paint from this color chord, allowing any development.

The colors emerging from this experiment often express the dynamic action of complements, usually present in contrast of hue but not always realized in its full potential. Contrast of hue is inclusive, like a party where everyone is invited, even at the last minute. Parties given in the spirit of complements are more exclusive but can achieve an even greater intensity—a scientist might be balanced by inviting an artist, or a young person by inviting an old one. Complementary pairs balance each other in the same way—they excite each other to their strongest brilliance and stabilize each other. They are opposite one another on the color wheel, and in the eye as well.

The physiological response inside the eye, which creates excitement and demands balance, underlies the experiments in the following contrasts, from the fiery intensity of dramatic complements to the brilliant shimmer of warm and cool to the earthy tones of contrast of saturation to the subtle luminosity of the simultaneous contrast. These contrasts depend on the vital balance of the complementary pairs, all of which have their own special qualities.

EXPERIMENT: Exploring Complements

Select any set of complements from colored paper and/or crayon or pastels. Let these two colors interact, first putting one down, and then asking what it needs beside it. As this harmony gets started, you may want to add the split complements—the two colors on either side of the main colors. These can be seen in all the illustrations here, from the red-orange circles in the thanka painting to the abstract improvisations. After exploring the different complementary pairs—yellow/violet, orange/blue, etc., try drawing the world with them, exaggerating the intensity. You might even reverse the colors you see into their complements, as in Alicia's yellow sky and blue hills. (below, right)

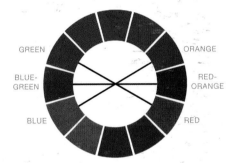

12-hue Color Circle, from Johannes Itten, *The Art of Color*, © 1961 Otto Maier Verlag Ravensburg, Reprinted with permission of John Wiley & Sons, Inc.

Alisa Klaus, pastel improvisation, 15 × 17 in. (left); pastel improvisation, 17 × 24 in. (right)

The interaction of blue-green, orange, and their split complements (top right) creates a dynamic abstraction (left) and a spatial magic when applied to a landscape (right).

Vincent van Gogh (1853–1890). *Café-Terrace at Night (Place du forum en Arles)*. Oil on canvas, 32 × 25¾, 1888. Rijksmuseum Kroeller-Mueller, Otterlo, The Netherlands, Photo credit: Erich Lessing / Art Resource, NY.

The dynamic action of a blue-violet night sky against a brilliant yellow-orange awning is repeated in the vibrating cobblestones.

Contrast of Dramatic Complements

I have added the word *dramatic* to Itten's original term "contrast of complements" to describe a particular expressive mode that combines the brilliance of complements with the drama of light and dark. This expression can be seen in the work of Vincent van Gogh, who uses the complements in a very conscious way. In his *Night Café* he speaks of "the terrible passion of humanity with red and green." In the portrait (below) he plays "orange tones, chromes and pale lemon yellow [against] the richest, intensist [sic] blue that I can contrive." He speaks of his *Café Terrace at Night* (opposite) as "nothing but beautiful blue and violet and green, and the lighted square of a pale sulphur and greenish citron yellow color." These same complements, blue-violet and yellow-orange, are inspired by nature in the last burst of afternoon light depicted by Linda Larsen in *For K.E.M.* (bottom right). The contrast of dramatic complements pushes the limits of both color and value, and like van Gogh himself, constantly balances the life force of fire with the dark power of earth.

Jackie Kirk, *Red Chard*, colored pencil, 12 × 17 in.
Natural complements appear in plants.

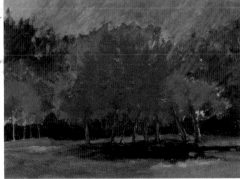

Linda Larsen, *For K.E.M.*, oil, 11 × 14 in., 1998
Blue-violet and yellow-orange in late afternoon light.

LEFT: Vincent van Gogh, *Eugene Boch, the Belgian Painter* (1855–1941). Oil on canvas, 60.0 × 45.0 cm. Photo: Hervé Lewandowski. Photo credit: Réunion des Musées Nationaux / Art Resource, NY. Musee d'Orsay, Paris, France.

Dark, intense, blue and yellow-orange create a mysterious effect.

contrast of warm and cool

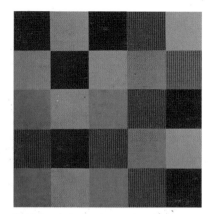

Checkerboard of cold and warm colors, Johannes Itten, *The Art of Color*, © 1961 Otto Maier Verlog Ravensburg, Revised Edition / 0471289280, Reprinted with permission of John Wiley & Sons, Inc.

The spatial excitement of red-orange, blue-green, and purple of the same value is expressed in a checkerboard format.

Christof Diermann, improvisation, *Mystic Splendor*, pastel

Geometric blocks of color have given way to softer layers of shimmery color, evoking light.

Contrast of warm and cool is perhaps the most distinctive and electric of all the complementary pairs, containing the strongest polarity. Red-orange is the warmest of all the colors, and we perceive it as being closer. Blue-green is the coolest and we perceive it as farther away. When these two complements are juxtaposed, it creates a spatial excitement in the eye that vibrates with light, as in Itten's checkerboard (left). The effect can be stunning, but to produce it we need to have the right range of colors in our palette of crayons and pastels, and/or an exactitude in mixing paint.

Evoking the Mystic

Before we go further into the special requirements of warm and cool contrast, we will first explore its elemental, emotional quality. Read the following paragraph from Itten's book describing warm-cool contrast. As you read it, notice any sensations, feeling states, and colors that come to you.

> These works were . . . created so that the material sense of man may be directed to that which is beyond matter They were . . . "flashing hieroglyphs," intelligible to all. Their mystic splendor gave the faithful an experience of radiant transcendence. This visual experience was a direct invitation to higher spirituality.

EXPERIMENT: Color Improvisation

As you read this description, what inner sensations do the terms "mystic splendor" and "radiant transcendence" evoke? What colors come to you? When you have chosen a color chord, draw or paint spontaneously with those colors, allowing the movements and shapes to emerge naturally. When your work feels complete, take time to see the forms and colors that have emerged, noticing their effect on you.

The intuitive color chords and drawing improvisations inspired by Itten's description of warm-cool contrast often move spontaneously toward the inherent qualities of the warm and cool contrast. The geometry of the primary colors of contrast of hue shift to more flowing, circular forms. Layers of secondary colors: green, purple, orange—close in value—emerge in response to the term "mystic splendor," evoking the immaterial, "shimmery" effect of air, light, and water. These characteristic qualities of warm-cool contrast grow naturally from an intuitive knowing, not from conceptual learning.

EXPERIMENT: Exploring Warm and Cool

Although you have expressed the qualities of the warm and cool contrast in an intuitive way, to intensify and sustain the visual effects it is helpful to explore them more objectively. Begin by finding the colors at the heart of this contrast: the complements red-orange and blue-green. Also include the color purple (from blue-violet

to red-violet), as it is an important ingredient in warm and cool, acting as a cool to the orange, and warm to blue-green. Notice this action in the checkerboard (opposite, top), and match the colors, creating a similar pattern. If you are using pastels or crayons, buy a set that includes these core colors, along with their lighter versions, or buy them individually. If you are using paint, take the time to mix red-orange, blue-green, and purple, using the mixing instructions in chapter 9, Media (see pages 170–173). As you play these colors against one another, you will discover the electricity created when they are the same value. Like striking a match, they can generate their own sense of light.

We can see an example of this spontaneous development (right) in which blocks of core colors break into wider bands even closer in value, which dissolve into smaller, overlapping strokes. These strokes create a whole field of light, which becomes more important than the action of individual colors. We move from the rugged individualism of contrast of hue into a more harmonic community, in which individual cooler colors (blue, green, purple) give up their intensity in order to vibrate with the lighter oranges and yellows. This vibrating field of "broken" color is the basis of the Impressionist technique utilized by Monet in capturing the ineffable shimmer of light on a haystack in *Haystack at Sunset* (below).

David Newell, mixing warm and cool, casein

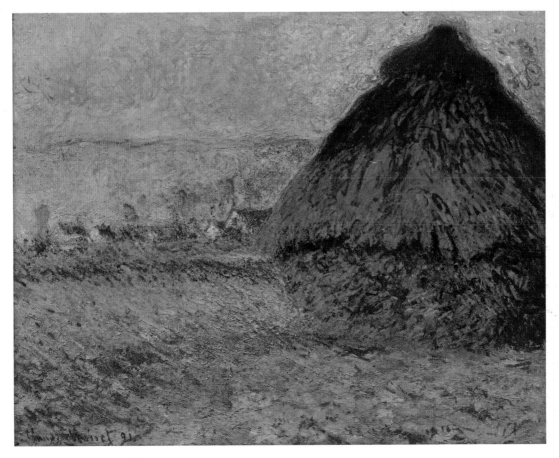

Claude Monet, *Grainstack (Sunset)*, oil on canvas, 28 7/8 × 36 1/2 in., 1891. Museum of Fine Arts, Boston, Juliana Cheney Edwards Collection, 25.112. Photograph © 2008 Museum of Fine Arts, Boston.

Blocks of red-orange, blue-green, and purple dissolve into a field of light (above). We can see the same dynamic in Monet (left), in which every color is distributed throughout. Notice especially the purple, which is layered on everything—darker in shadow, lighter in the light.

Georges-Pierre Seurat, *Study for Les Poseusses*, oil, 24 × 16 cm, 1887–1888
Seurat creates a sense of light with small strokes, described as Pointillism.

. . . [By] the exclusive use of the optical mixture of pure colors, . . . the neoimpressionist insures a maximum of luminosity, of color intensity, and of harmony . . .
Paul Signac

EXPERIMENT: Exploring Broken Color

After you experiment with the electricity possible with the core colors, experiment as well with application. In the experiment exploring warm and cool, you may have noticed a tendency for the colors to break into smaller strokes. Now, consciously experiment with this tendency, letting the strokes become more distinct from one another. Let these strokes build into layers so that colors are not only vibrating next to one another, but overlaying each other as well. This resembles the "broken color" of the Impressionists, or even the Postimpressionist technique of Pointillism, exemplified by Seurat. This is not so much a technique to be mastered as a possibility to be explored. Smaller strokes leave no resting place for the eye, allowing the full action of the warm and cool palette.

After you have a sense of this possibility, experiment with matching all the values to the lighter yellows and oranges. Then try the darker end of the spectrum and the vibrant action between the different blues, greens, and purples. You can see the lighter range expressed in Art Holman's *Yin Tree* and the darker range in his *Under the Pond* (see page 78).

EXPERIMENT: Working with Images

As you explore the range and natural tendencies of the warm and cool palette, allow images to emerge from these colors and strokes, either from your imagination or from the world around you. As you draw or paint from landscape, figures, flowers, etc., convert everything you see into vibrating light, no matter what neutral colors or definite forms you are actually seeing.

The interaction of colors in the extended abstract study (opposite, top left), inspired by listening to Indian Raga music, can be seen in the landscape painting done later on location (opposite, top right). Painted on a purple ground, this pastel painting is built up from many strokes of blue, orange and purple, vibrating next to each other. Although the landscape was started on location, it needed more layering in the studio to match the sense of October light in a magical canyon in the eastern Sierras.

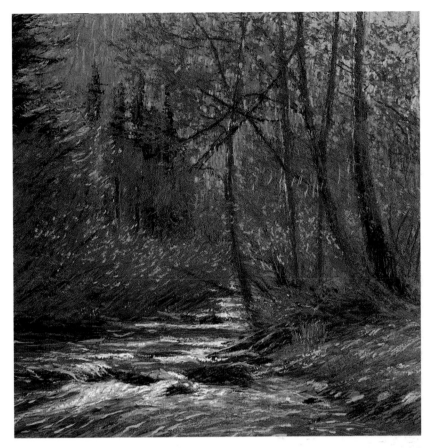

Connie Smith Siegel, extended warm-cool study, casein (above);
Aspens and Stream, Lundy Canyon, pastel, 19 × 19 in., 2000 (right)

The many layers of blue, orange, and purple pastel in
the landscape create a sense of October light.

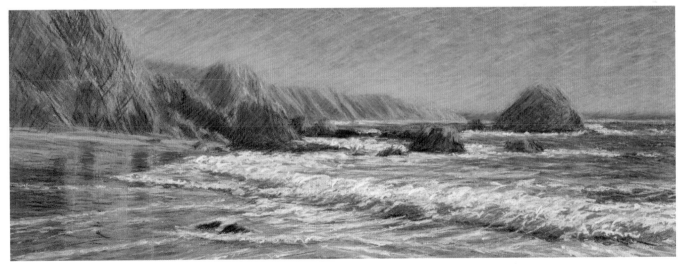

Connie Smith Siegel, *Late Afternoon McClure's Beach*, pastel, 12 × 30, 2005

The orange glow on the cliffs contrasts with the blue-green of the water, built up with many layers.

the union of color and light

Pierre Bonnard (1867–1947) *Dining Room Overlooking the Garden (The Breakfast Room)*, oil on canvas, 62⅞ × 44⅞ in., 1930–1931. Given anonymously. (392.1941). © 2008 Artists Rights Society (ARS), New York / ADAGP, Paris. Digital image © The Museum of Modern Art/Licensed by SCALA / Art Resource, NY. The Museum of Modern Art, New York, NY, USA

Bonnard captures the cosmos in small cups.

Light, that first phenomenon of the world, reveals to us the spirit and living soul of the world through colors.

Johannes Itten

The experiment on working with images parallels the Impressionist technique of filling the canvas all over with small strokes of pure color, a technique "invented" by artists like Monet and Pissaro, as they eagerly pursued their passion for light. This passion continued in the work of Bonnard, whose vibrating strokes weave the surface with pulsing light, carrying the plein air (outdoor) painting of Monet into the more abstract world of Matisse, both of whom were inspired by the visual world but created a parallel universe that expanded the possibilities of color and light.

EXPERIMENT: Working from Paintings

Take the time to really see these paintings. What feelings are evoked as you see them? Where do the colors and movements resonate in your body? Is there a movement quality or a sound that can grow from these sensations? When you are ready, pick pastel or crayon colors that feel right, and let the movement be carried to paper. Your first effort might start as a series of colored drawings that reflect your impressions and continue them in your own way.

Once you have explored your personal responses, look carefully at these paintings again, with the intension of actually working from them. Choose one of the paintings here, and make a copy of it with colored drawing or painting media.

Seeing and working from paintings can be a demanding but important way to explore the vocabulary of warm and cool, whether in ten-minute improvisations or longer sessions. By reproducing a painting in some detail, you can more fully understand the magic of color that gives life and dimension to a flat surface. Most of the Impressionists learned their craft in this way, often beginning their careers by copying master paintings in the Louvre. (In addition to copying more traditional masters, Matisse studied a small painting of Cezanne's for decades to better understand the composition and color.) Although it is best to work from real paintings, reproductions can also give us a wide range of expression.

Pierre Bonnard (1867–1947), *Sketch for Dining Room in the Country*, pencil, 1930–1931. Private collection (right); *Dining Room in the Country*, oil on canvas, 64¾ × 81 in. (164.29 × 203.52 cm), 1913. Minneapolis Institute of Arts. © 2008 Artists Rights Society (ARS), New York / ADAGP, Paris (below).

Although Bonnard has created a parallel world of light, it is firmly grounded in his visual experience, as we can see from this copy of a small study that preceded the painting. From these intimate observations, everyday reality becomes integrated with the transcendent reality we see reflected in the stained glass windows of the great French cathedrals such as Chartres.

the healing world of light

The tendency toward all-over composition in the warm-cool contrast matches the theories of quantum physics, in which everything is part of a field of moving particles. As we enter this spiritual realm, "beyond matter," solid objects and their clear defining edges are an illusion. Individual differences, often conflicting, can dissolve in this larger, light-filled world, just as seeing Earth from a distance in outer space can give us a unified vision of the planet.

It isn't necessary to travel so far to experience this spirit-filled world—it can be found in the vibration of color inherent in the warm and cool contrast. We see it not only in stained glass windows and Impressionist paintings but in the work of contemporary painters like Art Holman as well. Deeply inspired by light in nature, Holman produces his large paintings over a period of months in the studio. In a manner parallel to Monet's water lilies, he builds up layers of oil paint, balancing the forces of warm and cool, light and dark. The paintings here reflect important polarities within warm and cool. The lighter value of *Yin Tree* (left) is keyed to bright yellow, while *Under the Pond* (below) explores the darker blues inherent in water. *Horus Star* (opposite) radiates with the dark glow of outer space.

Although not everyone will choose the contrast of warm and cool as a creative base, it is important to understand the principles of this contrast, as they account for luminosity in painting. But now you may find yourself yearning for solid forms again, balancing our excursion into light with the forms and colors of earth.

Art Holman, *Yin Tree*, oil, 66 × 30 in., 1989 (above); *Under the Pond*, oil, 60 × 72 in., 1995 (right)

Holman combines observation of nature with a sense of inner light. *The Yin Tree* (above) is keyed to bright yellow. *Under the Pond* (right) merges water and light in deep blue-green depths.

Living in the San Geronimo Valley in Marin County and walking and hiking in the woods and hills has given me my subject matter: nature, light, color, with an abstract matrix.

Art Holman

Art Holman, *Horus Star*, oil, 67 × 57 in., 1985

Glowing from outer space, the archetypal composition of *Horus Star* matches the underlying structure of Grunewald's *Resurrection of Jesus*, painted in 1512–1516 to reveal the healing world of light beyond earthly chaos and pain.

expressive color: back to earth

The expression of vibrant color has long been a call to life and regeneration in cultures all over the world. But now we will explore another expressive principle—the powerful voice of the earth, compelling and absolute. This voice is carried by the contrast of light and dark, an expressive mode uniting all artists, from early pictographs to the most sophisticated works of Eastern and Western traditions. From the ancient caves of Lascaux to the classical drawings of Poussin, the language of lines, value, and shape directly express the forces of gravity and the inner sensations of movement, touching, weight, and balance. The structural clarity of light and dark defines the composition for the subtle contrasts that follow.

Nicolas Poussin (1594–1665), *The Marriage of the Virgin*, brown ink, brown wash, 13.2 × 20.1 cm. Photo: Michele Bellot, Louvre, Paris, France. Photo Credit: Réunion des Musées Nationaux / Art Resource, NY. Known for their classical values, the drawings of Poussin reflect a universal passion for shape and balance.

contrast of light and dark

Although we have focused on painting and drawing in exploring the Itten contrasts, the creative dynamics of color go far beyond this—expressing the eternal cycles of growth and death. Life rises from the earth to be nourished by the sun and returns to be regenerated. The certainty of death and the promise of eternal life are at the core of religious belief, from ancient myth and ritual to contemporary forms of faith. The Itten contrasts reflect these cycles, expressed in the archetypal patterns of earth, air, fire, and water inherent in our own bodies. By focusing on each element, one at a time, we reclaim our full natural resources—not only in painting but also in our whole lives.

So far we have focused on fire, water, and light—the full-bodied contrast of hue that radiates all the colors of the sun—and the vibrant intensity of the complements. The magic of these contrasts comes through our sense of seeing. But there is yet another world to explore as we move beyond vision into the expressive potential of our whole body: our inner feelings, and the sensations of touching and weight. Through these sensations we connect with the earth.

The relationship of these inner sensations to the contrast of light and dark becomes clear when we, for the first time, experiment with a black medium on white paper.

EXPERIMENT: Exploring Light and Dark

To explore the contrast of light and dark, select a black crayon or pastel and a large sheet of white paper. Let your first marks on the paper evolve in any way—into lines, textures, and shapes, even images if they appear. As you work without color, notice any difference in your state of being. What sensations or feeling states does this exploration awaken? Especially after the intensity of the previous color contrasts, you might feel a sense of relief with this more down-to-earth exploration. Select additional light and dark drawing media (charcoal, graphite, etc.) from the list on pages 164–165 and notice the different qualities they produce, from stark black-and-white to subtler shades of gray and white.

Honalore Fischer, first light/dark experiment (left); Lauren Schwartz, light/dark improvisation (right)
Forms can echo the movement of planets and the curve of the earth (left) or grow spontaneously like the origins of life (right).

The Falling Cow, #40, from *Cave of Lascaux, The Final Photographs*, by Mario Ruspoli, Harry Abrams, publisher.

Through line, shape, and movement, prehistoric artists brought living creatures into visual form.

Take as much time with this experiment as you need, moving to a second or third drawing if it interests you. When you feel finished for now, take time to see what has emerged in your work. You might be surprised at the expressive potential of light and dark, which can range from strong, dark, abstract shapes to delicate lines and/or subtle shading. Using only the simplest of tools, a whole world of power and diversity is waiting to be explored.

> *In this moving universe [Lascaux] no barriers have yet been set up between the animal, vegetable and even mineral kingdoms; there are only different aspects, changing appearances. A single current of life circulates through all creation. Everything that exists is alive, and everything that is alive is united by powerful bonds of solidarity.*
>
> Mario Raspoli, ethnologist

After experimenting with bright color one can feel a palpable sense of relief, a sense of coming home, with the simplicity of working light and dark. As we see our drawings, we can feel the earth speaking through them—a primal language of shape and space often reminiscent of prehistoric artists from the caves at Lascaux. As we begin the next experiments and see the historical masterworks that exemplify these subtle contrasts, it is important to remember the primal source of their expressive power.

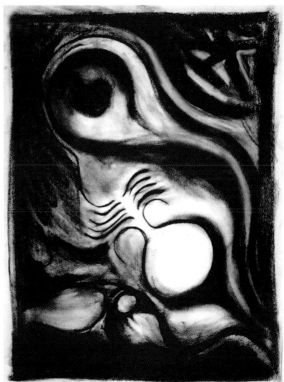

Io Anna Sinoux, first light/dark experiment, charcoal

The forms in the first light and dark experiments can reflect the natural cycles and the primal mysteries of prehistoric art.

Above all you must study values . . .
for this is the basis for everything,
and whatever way one may feel and
express oneself, one cannot do good
paintings without it.

Corot (speaking to Pissaro)

Contrast of Light and Dark: Shading

When nineteenth-century master Corot stressed the importance of "values" to the young Pissarro, he was referring to the essentially unwritten language of form that dominated Western painting for centuries. We can see the visual vocabulary of this language in the twelve-tone value scale (below), which shows the polarity of black and white and ten tones of gray in between. Compared to the expansive world of color we have just explored, the simplicity of the value scale may seem sparse and limited. And yet the contrast of light and dark underlies some of the highest achievements in art, not only in the European masters we have come to revere, such as da Vinci, Rembrandt, and Corot, but in the great tradition of Chinese and Japanese painters, calligraphers, and printmakers.

EXPERIMENT: Exploring the Value Scale

One expressive element that can emerge with the first light and dark improvisations is shading—the subtle graduation of grays between the black and white of the twelve-tone value scale. To explore shading, draw the outline of this scale on the bottom of a page, and then fill in each of the twelve tones, making each distinction clear. In another, more intuitive scale, move quickly through these twelve tones, shading with a smooth transition from light to dark.

After you practice the value scale, try some simple shading on a sphere. First draw the outline of a circle and then gradually shade the sphere, with the darkest value at the edges and the lightest in the center. The three-dimensional effect created is called chiaroscuro, an Italian term that defines pictorial representation in terms of light and dark modeling without regard for color.

Connie Smith Siegel, value scale and three-dimensional shaded sphere (above); Jo Johnson, shading experiment, charcoal (right); Twelve-tone value scale (edited), Johannes Itten, *The Art of Color,* © 1961 Otto Maier Verlog Ravensburg, Revised Edition/0471289280. Reprinted with permission of John Wiley & Sons, Inc. (top).

Spontaneous shading (right) evolves from a value scale (top). It can also be applied to modeling a circle (above).

As you explore these effects, notice the masterful use of shading in the drawing of Seurat (below), slowly and carefully built up with wax crayon on textured paper to obtain the three-dimensional effect. To experience first hand the coordination of hand and eye that resulted in his convincing volume and subtle transitions, make a copy of this drawing using conté crayon or charcoal on charcoal paper. Begin slowly at first, laying out the forms with a light outline, then gradually build up the volume.

The fascination with volume and space flourished in the Renaissance due to the subtle transitions possible with oil paint. But for the most part, the mastery of shading excluded color or strongly limited its effects. In the self-sufficient and powerful world of chiaroscuro, color is not appropriate, or even welcome. It would seem that the contrast of value and the vibrant color contrasts we have just studied are incompatible.

But three-dimensional shading is not the only function of value contrast. There are other expressions of light and dark, which not only support the vibrant use of color but greatly expand our journey of self-discovery.

Calm of tone is given by an equivalency of light and dark.

Georges Seurat

George-Pierre Seurat (1859–1891). *Seated Boy with Straw Hat, study for Bathers at Asnieres.* Black Conté crayon on Michallet paper, 24.1 × 31.1 cm (9½ × 12¼ in.), 1883–84. Everett V. Meeks, B.A. 1901, Fund 1960.9.1. Photo credit: Yale University Art Gallery / Art Resource, NY. Yale University Gallery. New Haven, Connecticut, USA.

Shading creates volume in the figure and the surrounding space as well. Besides the three-dimensional shading there is another expressive element in this drawing we will next explore: the expressive power of the light and dark shapes.

Contrast of Light and Dark: Abstraction

Although shading can offer three-dimensional effects, we will now explore another, more universal expression of value that will bring us to a primary source of personal form and composition.

EXPERIMENT: Exploring the Ground

With the same black crayon you used before and a new sheet of paper, make another value scale on the bottom of the page, only this time with your eyes closed. Notice the quality of touch and pressure it takes to make something gradually darker and lighter without the help of seeing. As you become aware of these sensations, let the value scale go, but continue to draw with your eyes closed. Where does your hand want to go on the paper when there is no "task" to perform, when it is simply guided by the sense of touch and weight?

At the end of this exploration, notice the distinctive shapes and rhythms that emerged by themselves when your hand is freed from restrictions. To explore these forms in another drawing, first spend time touching the paper with your eyes closed, experiencing the actual "ground" of your next drawing. When you feel ready, pick up your crayon and continue exploring, letting the contact with the paper guide the way. Try this drawing process at least two or three times, touching the paper first, letting each drawing be a whole new journey.

As you look at your drawings later, can you see the forms on the page as just exploration, without judgment? You may be disappointed or delighted with the results, but either way you are seeing your own nature, an inner portrait released and acknowledged perhaps for the first time. The forms you are seeing are directly communicating your state of being, speaking in a potent but perhaps mysterious language. To understand your forms more fully, we will continue with another experiment, this time with eyes open.

When what you do just comes out of nothingness, you have quite a new feeling.
Susuki Roshi,
Zen Mind, Beginner's Mind

Working from my closed-eye drawing improvisation (left), I made a value study (center). Finding that unsatisfying, I made a second value study that felt closer to the original spirit (right). If you are curious, make a tracing from the original, and fill it in yourself, noticing your own choices.

EXPERIMENT: Discovering Your Shapes

Choose one of your drawings that might be asking for more attention and take time to see it, noticing any inner responses. Do you see any shapes in the lines? Starting with a shape that attracts your attention, fill it in with either black or gray. Then let this shape lead to the next, until each area of the paper is black, gray, or white. As the forms emerge, they will begin to have a life of their own, eventually creating a coherent pattern or design on the paper. No longer creating a three-dimensional illusion of space, you are creating spatial relationships: shapes and spaces that speak an expressive language in their own right. We can call these drawings value studies.

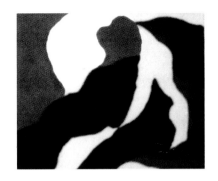

As you choose these forms with eyes open, you are developing your inner portrait, a reflection of your whole body. Sometimes it takes a few drawings to find the right forms. If the first value study is unsatisfying, the next one may feel better. There are no rules of composition here, only your own inner sense. When choices are expressed clearly in light and dark shapes, your inherent sense of balance will always lead you into a unified design. These choices of shapes and spaces have nothing to do with drawing ability or talent; they are simply reflecting who you are. The unique qualities of these forms are enduring, as we can see from Lynne Brown's drawings (right), twenty years apart yet still characteristic of her style.

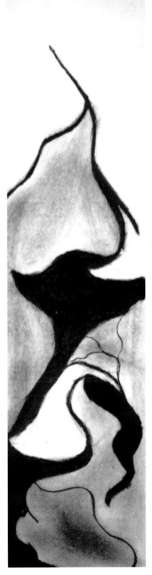

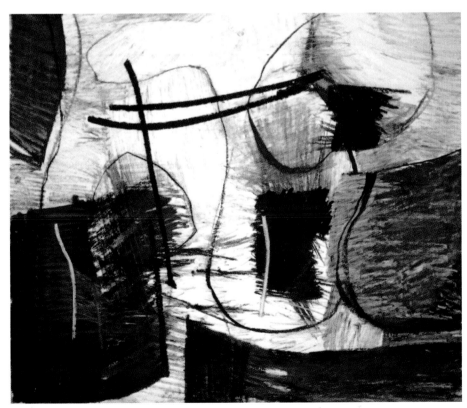

Regina Krausse, light and dark improvisation, charcoal and eraser, 18 × 24

We don't have to invent our own unique shapes; we simply need to make them visible.

Lynne Brown, value study, 1979 (top); value study, 1999 (bottom).

Lynne Brown's distinctive shapes remain constant, even after twenty years.

personal forms: individual and archetypal

A lthough the unique qualities of your light and dark forms are the source of personal style, they are also part of a more universal, archetypal language, shared by all artists, no matter what their cultural orientation or place in history.

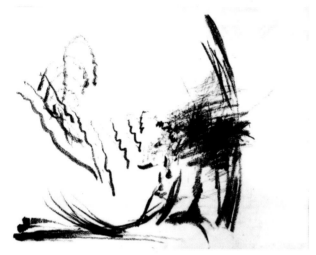

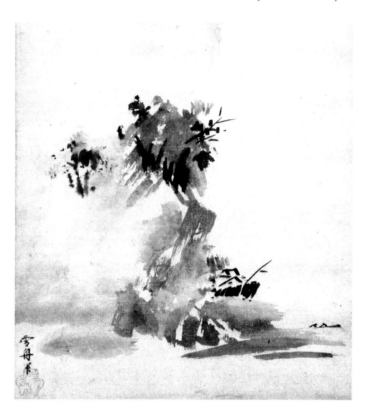

Gail Robertson, improvisation with closed-eye value scale (above); Shesshu (Japanese, 1429–1507), detail of mountain landscape, brush/ink. Tokyo National Museum. Image: TNM Image Archives (right)

Gail Robertson's spontaneous work, drawn with eyes closed (above), is the source of her style. This immediacy is paralleled in the meditative work of Japanese calligrapher and painter Shesshu (right), whose strokes reflect the chi, or life force, of the artist. Both play the lower horizontal line of earth against the upward movement of growth.

If the empty spaces are right, the whole body is alive, and the more such places there are, the less boring the whole thing becomes.

Ch'ing master

Danya Willard's shapes parallel the organic forms of Hokusai's *Waterfall*.

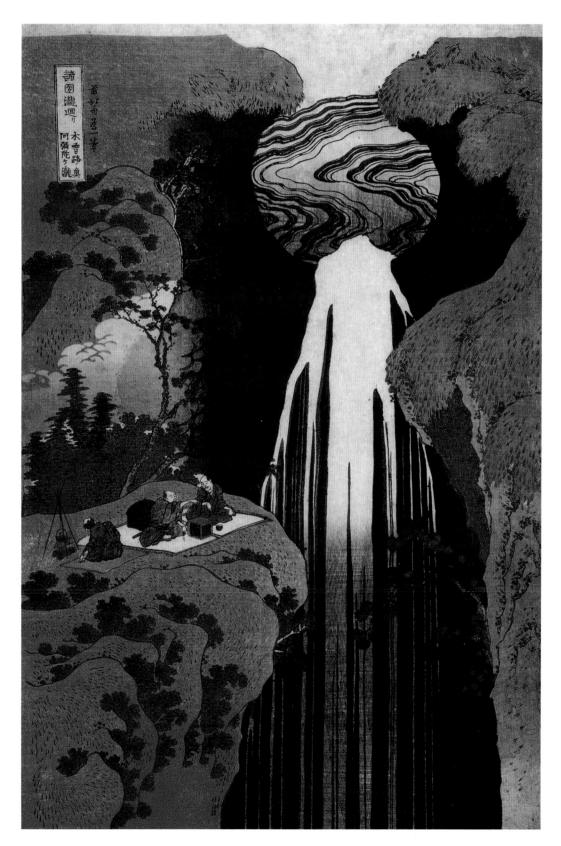

Hokusai, *The Amida Waterfall on the Kiso Road*, woodblock, 38 ¾ × 26 in., 1834–1835, private collection

Hokusai combines the archetypal shapes of notan with specific detail, holding dual forces in unity.

the principle of notan:
personal form as composition

Inspired by the use of value in Japanese painting, American educator Arthur Dow defined the expressive use of light and dark we have been practicing as "notan," a Japanese term that describes the harmonic distribution of light and dark within a picture. Notan is based on the yin/yang principle of dual forces held in unity, each force having equal importance. Instead of a three-dimensional figure against a passive background, we have the interaction between positive and negative space, as we can see in Hokusai's *Waterfall* and in Dow's use of notan in his *Bend of a River* variations. Dow's philosophy and his book *Composition* strongly influenced the work of Georgia O'Keeffe, as evident in the integration of personal form with compositional structure (the unifying principle of notan) in *From the White Place* (opposite).

Arthur W. Dow, *Bend of a River*, color woodblocks on paper, two variations, 4 3/8 × 7 in., circa 1898. Mr. and Mrs. George N. Wright.

Dow changes the season in these two woodblocks from summer to winter, using similar forms but different notan decisions. These choices carry the essential message of the prints.

Flat relations of tone and color are of first importance; they are the structural frame while gradation and shading are the finish.

Arthur Dow, *Composition*

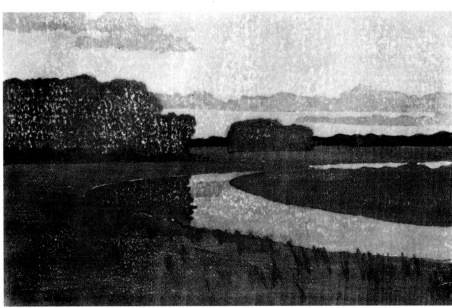

Under O'Keeffe's convincing three-dimensional shading of the cliffs, the light and dark shapes of notan create compositional unity, the source of her personal style.

This man had one dominating idea: to fill a space in a beautiful way——and that interested me. After all, everyone has to do just this——make choices——in his daily life, even when only buying a cup and saucer. By this time I had a technique for handling oil and watercolor easily; Dow gave me something to do with it.

Georgia O'Keeffe

Inner Exploration Through Notan

The connection between notan, individual difference, and emotional states came to me in 1972 when I took part in a three-month residential workshop in art, healing, and Gestalt therapy given by Virginia Veach. An essential part of our work together was based on "morning drawings," done with eyes closed, first thing in the morning under the influence of our dreams, and later filled in with black, white, and gray. The forms created provided direct access to our emotional life and also revealed a powerful sense of personal uniqueness in every participant.

I discovered that the recognition of light and dark shapes, so necessary for painters, is not as dependent on art education as on a primal instinct we share with every living creature. This primal instinct is demonstrated in the way chickens run from the distinctive shapes of hawks or the way plants respond to morning light. We all respond to a common language of light and dark. As you find your light and dark shapes through drawing, you give this primal language a voice, a visual presence.

The abstraction is often the most definite form for the intangible thing in myself that I can only clarify in paint.
Georgia O'Keeffe

EXPERIMENT: Inner Exploration Through Notan

To fully explore your distinctive forms, practice this "morning drawing" experiment each morning over a period of weeks or months. First touch the paper all over, including the edges, then draw shapes with eyes closed. Open your eyes and fill in the shapes using black, gray, and white. Use light charcoal or pencil for your first lines, so you can choose some forms and erase others. In Virginia's workshop we made the gray from vertical parallel lines (thirty-four of them) to stabilize the forms. Experiment until you find a way that feels natural to you.

Connie Smith Siegel, morning drawing, 1973 (right); morning drawing, 1973 (far right)

Each day can bring new abstract forms.

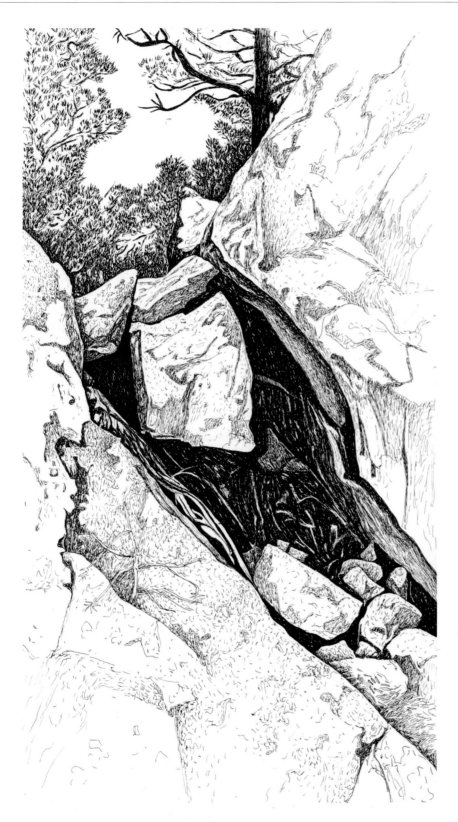

Connie Smith Siegel, *Rock Crevice, Colorado*, pen and ink, 1970 (left); morning drawing, developed, 1974 (above)

The abstract forms I drew from cliffs and rock crevices emerged later by themselves in the "morning drawing" process.

Finding Your Inner Forms in the World

As you fill in shapes in light and dark, you may find images emerging spontaneously, leading to surprising discoveries. Using the notan process to draw the forms you see in the world can be a most exciting adventure, uncovering a wealth of natural forms in your immediate environment.

One of the characteristics of great drawings is the artist's wholehearted acceptance of his own style and character. It is as if the drawing says for the artist, "here I am."

Nathan Goldstein,
The Art of Responsive Drawing

EXPERIMENT: Finding Your Inner Forms in the World

Look at the world around you, seeing everything as shapes and spaces instead of as hills, trees, figures, or objects. Draw what is in front of you, using the simple light and dark shapes you explored in the sensing value studies on pages 86–87 and the notan experiment on pages 92–93. In our previous experiments with color we drew with light, using primary and complementary colors. Now, as you convert everything to shapes and spaces of black, gray, or white, you are drawing with weight and mass, the elemental quality of earth.

Sometimes these abstract shapes will be obvious in what you're seeing, but just as often they will not and you'll need to choose them. The light and dark forms in your drawings may evolve in a different way than what you are actually seeing. No longer at the mercy of visual reality, you are centered in your own body, integrating the uniqueness of your inner forms with those in the world. Notice the individual differences in these four drawings from three different people drawing the same valley (below and opposite page).

Kay Carlson, notan study, charcoal, 1985

Light and dark shapes, equally balanced, simplify the many details of a forest stream.

Leila Joslyn, notan study, charcoal on gray paper, 3 × 7 in., 2003
The use of gray paper can give greater expression to the white areas. The boundaries are clear but not rigid, allowing free movement.

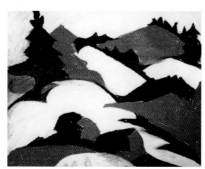

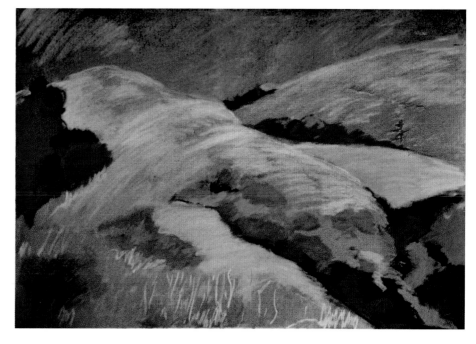

Alicia Klaus, notan study from hills, pastel, 14 × 16 in. (above); *Landscape*, pastel, 22 × 30 in. (right)

A clear division of shapes and spaces supports the strong color.

When the people of ancient times composed a large picture, they used three or four great divisions; thus they achieved a design of the whole . . .
Chinese master Tung Ch'i-ch'ang

Mbuti women of Zaire, painted bark cloth, 15x 23

A patterned language reflects forms of the African forest, unique to each tribe and yet universal.

David Miller, sensing drawing, eyes closed

The sense of weight in David Miller's closed-eye movement drawing (right) eventually led him to draw a rock formation, which offered a wealth of light and dark shapes, becoming more and more abstract (opposite top). Years later, David's notan drawings have evolved, combining observation with abstraction (opposite bottom). Notice the same abstract shapes in David's more realistic drawing.

Notan: The Union of Weight and Space

From native patterns to the ancient principles of Japanese painting studied by Arthur Dow to the present day use of notan in Gestalt therapy, light and dark shapes are fundamental to visual expression. Although these shapes are useful for effective composition in landscape and figurative work, the use of notan is more than a convenient technique. It is a fundamental body language, whose roots are deep in our tissues—our sense of weight and our sense of space—perceptions that keep us upright when standing. The impulse to balance and equilibrium is urgent and essential to our survival.

We can see the spontaneous evolution of this impulse in this series of drawings by David Miller, which began as a closed-eye drawing improvisation with a strong sense of weight (below). This sense spontaneously led him to a corresponding subject: a large rock formation. Instead of representing the three-dimensional surface of the rock with shading, he found flat shapes instead (opposite, top left). In the final abstract drawings these shapes became independent of the rock (opposite, top right), creating a balance of light and dark as definite as the patterned language of the forest tribe of Zaire. Years later, these unique but universal shapes appear in his representational drawings of hills and trees.

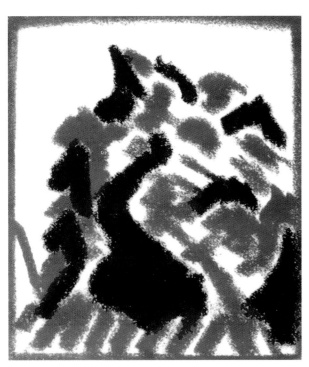

David Miller, notan studies from rock

*A hill or a tree cannot make a good painting
just because it is a hill or a tree.
It is lines and colors put together
so that they say something.*
Georgia O'Keeffe

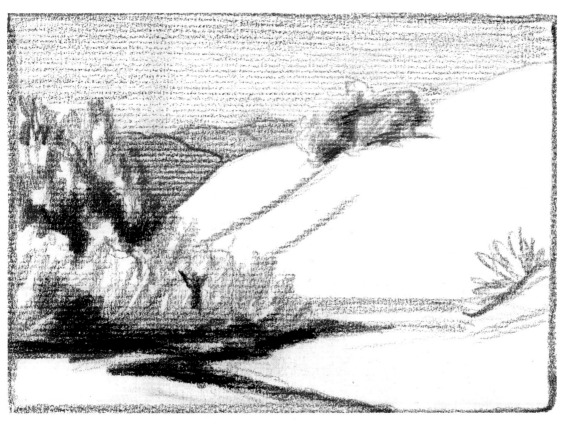

David Miller, notan study (detail), charcoal, 2006

Expressive Lineage of Notan

The artists who have endured in our Western tradition of art have the same power and simplicity of composition that we see in the Chinese and Japanese masters. This power does not come from realistic detail but from the relationship of lights and darks in the whole picture, which nineteenth-century painter Corot describes as "the mass, the ensemble which has struck you . . . that first impression by which you were moved." European masters such as Rembrandt, Caravaggio, and Goya have passed this unwritten language of abstract form from one generation to the next.

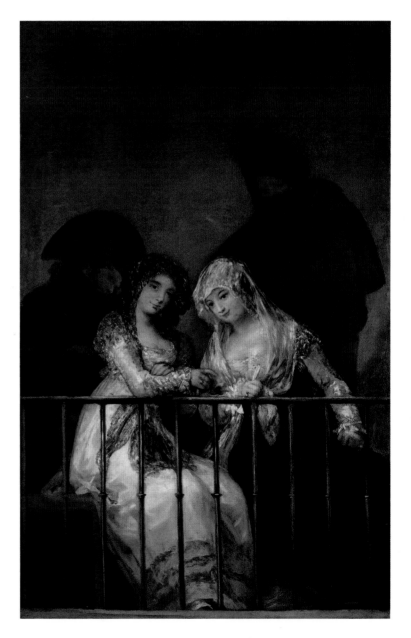

Emil Nolde, *Studies in Composition After Goya*, 1899. © The Ada and Emil Nolde Foundation, Seebull, Germany (above); Francisco de Goya y Lucientes (1746–1828), *Majas on a Balcony*, oil on canvas, 76¾ × 49½ in. (194.9 × 125.7 cm). H. O. Havemeyer Collection, bequest of Mrs. H. O. Havemeyer, 1929 (29.100.10). Image copyright © The Metropolitan Museum of Art / Art Resource, NY (right).

In this rare set of drawings (above), German Expressionist Emile Nolde is studying the light and dark composition of Goya (right), in the same way Beethoven studied the composition of Haydn, thus carrying on a lineage of musical form. Nolde has found the distinctive shapes and spaces that pervade Goya's work, underlying the detail and narrative content.

Pat Kriegler, notan study of Goya's *Majas* (far left); *Rock*, charcoal, 1998 (left)

Notice Pat Kriegler's notan study of Goya's *Majas* and the way in which she found these forms in a large rock.

EXPERIMENT: Study of Master Painters

Study the light/dark composition of master painters and printmakers for yourself. Beneath the realism, find the primal shapes that are distinctive to different artists and that unify the whole painting. Then, in the same way as Nolde (opposite left), make a value study of these abstract relationships, using black, white, and gray shapes.

Whatever the inward darkness may have been to which the shamans of those caves descended in their trances, the same must lie within us, nightly visited in sleep.

Joseph Campbell,
The Way of the Animal Powers

Just as Nolde continues the expressive power of Goya's compositions, you can also find affinities with master artists. As you discover and use their hidden structure, you continue a lineage of light and dark composition that goes back to prehistoric painting. Contained in your own unique shapes are the same elemental forms that convey magic and life in the caves of Lascaux and in contemporary art as well.

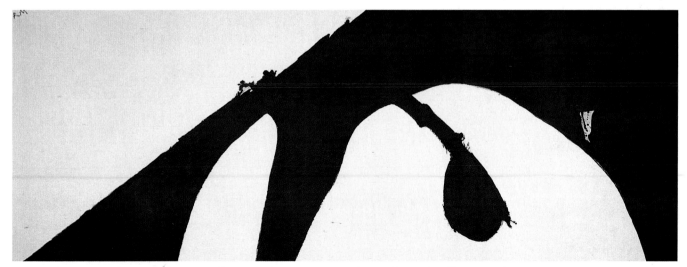

Robert Motherwell, American (1915–1991), *África*, acrylic on Belgian linen 81 × 222½ in., 1965. The Baltimore Museum of Art: Gift of the Artist BMA 1965.12

Motherwell's light and dark shapes echo the primal power we see in the Lascaux caves (see page 83), carrying magic and life.

natural forces made visible in light and dark

The primal forms we make are influenced by the interaction of natural forces—the fierce urge toward growth and awakening in the spring, and the return to earth that comes in the fading light of winter.

This obedience to gravity can be seen in the classical tradition in Western art, which reflects the harmony of forms in Greek temples. The temple pillars in Poussin's preliminary ink drawing (left) reflect this passion for stability and balance as he works out the underlying structure for a painting. He is finding the abstract forms that unify the many levels of meaning in his allegorical paintings. This geometric simplicity can also be seen in Richard Diebenkorn's *Woman in Profile*. He was influenced by the composition of modern masters such as Henri Matisse and Giorgio Morandi.

ABOVE: Nicolas Poussin (1594–1665), *The Marriage of the Virgin*, brown ink, brown wash, 13.2 × 20.1 cm. Photo: Michele Bellot, Louvre, Paris, France. Photo Credit: Réunion des Musées Nationaux / Art Resource, NY.

Poussin's drawing reflects his passion for balance.

RIGHT: Richard Diebenkorn, *Woman in Profile*, oil on canvas 68 1/8 × 59 in., 1958. San Francisco Museum of Modern Art. Bequest of Howard E. Johnson. © Estate of Richard Diebenkorn.

Diebenkorn has distilled many specific details to a geometric simplicity, integrating figure and landscape. Through the power of space they have become parts of one whole.

Never are lines drawn wildly,
never is a curve made without
thinking of it in relation to
a vertical or horizontal.

Henri Matisse

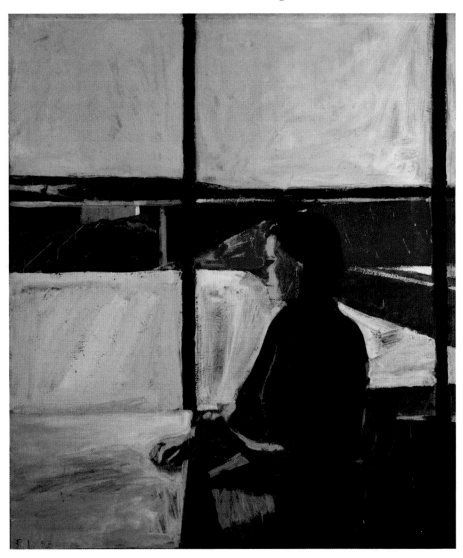

But underlying the classical tradition is the functional simplicity of the post-and-lintel system of the Greek temples themselves, with their vertical and horizontal lines reflecting the force of gravity. Even without studying art history, we can be influenced by these lines of gravity because they are right at hand, built into our drawing paper.

EXPERIMENT: Classicism, Near at Hand

To experience the classical influence, put a blank piece of paper in front of you and notice the vertical and horizontal lines that define the space. Can you feel the effect of these lines in your own body? Notice what happens to these lines and space if you rotate the paper 90 degrees. Then move the paper diagonally, one corner down. Do you feel any inner changes as you move the paper? Decide on the best position for the paper, and take the time to see it again. Does this empty space invite a line or a mark? Following your instinct, put down a line or mark, noticing how it changes the space. Does this line or mark ask for another? Trusting your intuition, add as many lines or marks as you need, each time noticing the influence on the whole space. If you are interested, take your choices even further, filling in the spaces with black, white, and gray.

Connie Smith Siegel, lines and notan
My lines are carefully drawn and then developed.

Beatrice Darwin
In contrast, Beatrice Darwin's tonal forms meet the space of the paper like a Samurai thrust.

Mila Mitchell, *Garage Interior*, pen and ink, 15 × 17 in., 1992
In her own way, Mila Mitchell continues the classical tradition. Her drawing comes from a long personal search for order in a world of emotional turmoil and shifting values. The balance between light and dark gives meaning to her life.

structure and emotion integrated

The forms you create in response to the space of the paper reflect an urge toward balance as ordinary as the sense that keeps you upright as you stand. This sense of equilibrium underlies the composition of all painting, no matter how sophisticated. Although light and dark composition always depends on the force of gravity, it is not always architectural. Forms of growth that seem to defy gravity have come to be associated with a style of painting we call Romantic. We can feel this defiance in the trees of Corot's *Windswept Landscape*, held by the earth but wildly thrown by the wind.

Whether classical or Romantic, improvised or planned, the interaction of light and dark shapes brings our inner life into the world. The abstract principle of notan reveals our feeling states, bringing us to the present, carrying the real emotional message. Although emotion is masterfully portrayed in the facial expressions and gestures of Baroque and German Expressionist paintings, it is the abstract movements that carry us into drama and hold us there.

Whether working abstractly or figuratively, we are always searching for our own particular, unique forms. And yet these personal forms are part of larger archetypes that can connect us deeply to other master artists.

Distinctive shapes are inherent within us, reflecting our most intimate feeling states, reminding us of what it is to be alive. When these personal forms are missing from our work, it is lifeless. No matter what skills or techniques we learn, without these inner forms we are never fully satisfied with our creations.

The principles of light and dark we have defined as notan are especially important in giving definition and structure to the world of subtle color—the earth tones of contrast of saturation and the luminous, muted harmonies of the simultaneous contrast. The use of notan will help you keep your center as you move into representational painting. It will remind you that even when you are depicting the detailed forms and colors of the visible world, you are always making an abstraction, always reflecting your inner world.

Linda Larsen; sensing drawing (left); *Under the Bay Tree*, notan study, crayon on toned paper (right)

The diagonal forms of Linda's sensing drawing (left), arising from direct feeling, are echoed in an earlier drawing of a forest tree (right). Linda's forms are parallel to Corot's trees (opposite), bending in response to natural forces, but firmly held by the earth.

*(Always keep in mind) . . . the mass,
the ensemble which has struck you . . .
that first impression by which you were moved. . . .*

Jean-Baptiste-Camille Corot

*Be guided by feeling alone . . . follow only
what you understand and can unite
in your own feeling. . . .*

Jean-Baptiste-Camille Corot

Jean-Baptiste-Camille Corot, *Remembrance of Lake Nemi*, drawing, 7 × 10 in., 1865–70

Jean-Baptiste-Camille Corot, *Le coup de vent, (Windswept Landscape)*, 18 × 23, oil, 1865. © Musée des Beaux-arts de la Ville de Reims. Photographer: C. Devleeschauwer.

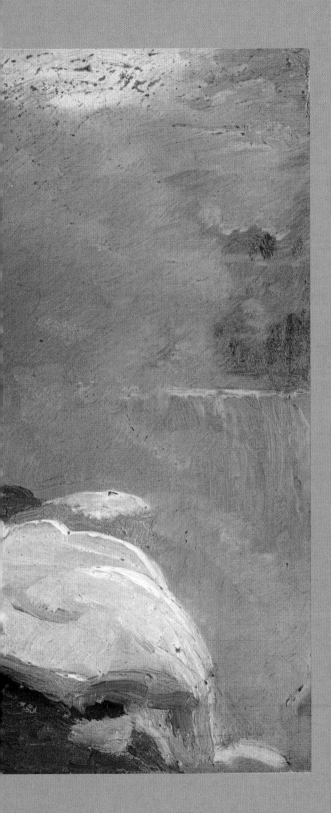

contrast of saturation

Our exploration of the earth continues in contrast of saturation, defined as a large amount of neutral(s) played against a small amount of saturated, bright colors. In its emphasis on neutral colors, contrast of saturation brings us to an appreciation of the many grays, tans, and browns that make up our visual world. Far from being an esoteric preference, this subtle contrast defines the Western and Eastern master traditions of painting, from Rembrandt to Hokusai to the subtle abstractions of Morandi, Braque, and Klee. Contrast of saturation communicates a quiet reassurance and enduring love of the earth, from contemporary realists such as Andrew Wyeth to indigenous people all over the world.

Frederic Church (American, 1826–1900) *Niagara River and Falls in Snow*, brush and oil paint, graphite on paperboard, 197 × 300 mm (7 ¾ × 11 ¹³/₁₆ in.), March 1856. Cooper-Hewitt, National Design Museum, Smithsonian Institution. Gift of Louis P. Church; 1917-4-765-c. Photo: Matt Flynn.

Frederic Church was a pioneer of plein air painting, combining the personal touch of drawing with closely observed, subtle color.

the language of earth

Jan Gross, improvisation: *San Geronimo Valley in Winter Rains* (below)

Jan Gross's muted color chord (above) evokes a particular season and place, as expressed in her painting (below).

Light and dark composition can expand our personal expression in the brighter contrasts, but it is essential in the subtler ones. Contrast of saturation (using only a small amount of bright color against a large amount of more earthy neutrals) is a perfect partner for light and dark contrast. Neutral browns, grays, whites, and tans often go unnoticed, waiting for the clarity of light and dark to bring them to life. In return, these muted tones can bring richness to the light and dark forms we have just explored, without diminishing their power.

EXPERIMENT: Evoking Earth

Before defining these colors more objectively, we will first explore their evocative qualities with drawing and color. Begin by closing your eyes. Focus on the element of earth, feeling any sensations inside, noticing any colors that come to you spontaneously. The colors could arise from your immediate sensations or be associated with a particular occasion or place. Pick your color chord from the pile of colored papers, and then let a drawing grow from it, using a toned drawing paper (gray, black, brown, tan) that resonates with your feeling. The evocation of earth can bring forth a rich variety of neutrals, often with a small amount of bright color.

EXPERIMENT: Coming Down

What comes to you if you close your eyes and focus on something in your life that "brings you down"? Whether it is in the past or present, notice what sensations/feelings you experience and what colors arise. After you pick a color chord and drawing paper, let this feeling express itself in drawing, accepting any form it takes.

Although some people might interpret "coming down" as connecting to the earth, for many it evokes feelings and events that are uncomfortable, even painful. We can see that every aspect of living, even pain or death, has its own kind of beauty. In the somber colors that often emerge in this experiment, we can hear a song of the earth, enduring and compelling.

To begin writing from our pain eventually engenders compassion for our small and groping lives. Out of this broken state there comes a tenderness for the cement below our feet, the dried grass crackling in a terrible wind. We can touch the things around us we once thought ugly and see their special detail, the peeling paint and gray of shadows as they are—simply as they are: not bad, just part of life around us—and love this life because it is ours, and in the moment there is nothing better.

Natalie Goldberg, *Writing Down the Bones*

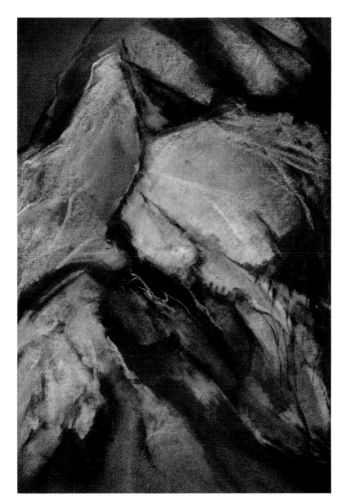

Pat Kriegler, *Study of Rock Formation*, pastel on brown paper, 2000 (left); Improvisation: *Death of a Friend*, oil crayon (above)

Pat has found the beauty of neutral tones in nature, but even pain and sorrow have their own kind of beauty.

the vocabulary of earth:
colors without names

These leaves, scanned directly, contain a whole vocabulary of color, expressed later in the color chord.

Connie Smith Siegel, *Train Ride Through the Mountains*, casein, 9 x 12 in
Snowfields abstracted from a sensing drawing.

We can explore neutrals in the same way as Paul Klee, using the geometric simplicity of his format in *Fire in the Evening* to see the subtle variations of neutral colors more clearly.

EXPERIMENT: Exploring Neutrals

If you are using pastels, separate the neutrals from the set and play them against one another in a checkerboard, or layered, format. If you need more neutrals, buy them individually and/or layer them to attain the subtle ranges you want. If you are mixing colors in paint, you can obtain neutrals by simply adding black, white, or gray to any color on the color wheel. You can also attain luminous grays and browns by mixing complements, adding white as needed to modify the neutrals (see pages 172–173.) Play the neutrals against one another or against more intense colors.

EXPERIMENT: Seeing the World

The real vocabulary of contrast of saturation can be found in the earth itself and the everyday world we inhabit. To experience this vocabulary, go outside and bring in anything you are drawn to. Arrange what you have found on a piece of white paper so the colors can be seen clearly. Much of what you find could be defined as "trash," but in this new context it can become precious. Your undivided attention can reveal the real beauty of these usually forgotten colors of the world. Let the colors you are seeing inspire a color chord. From this chord create a simple geometric composition or checkerboard, either drawn with crayon or pastel or painted.

Taking the time to see and work with these neutral colors can be a meditation, a creative act in itself. The gray and ochre shades of decaying newspaper, fallen leaves, and the undersides of rocks and the variety of rich browns and grays in the soil can emerge in their true luminosity, all the more compelling because they have been here all the time.

EXPERIMENT: Reflecting the World

Extend your attention to the world around you as if it were a pile of colored papers, as flat shapes of color. As you set aside the specific identity of objects, you can experience some of the innocence of seeing something for the fist time, whether it is a spectacular vista or the ground under your feet. As you observe this totally ordinary but uncharted world of color, make a simple drawing diagram, and write in the word for each color you are seeing. Then pick a color chord for what you have seen, and create an abstract composition in paint or pastels (such as the one at bottom left), following the forms in your drawing diagram or using a checkerboard format.

Paul Klee (1879–1940), *Fire in the Evening*, oil on cardboard, 13⅜ × 13¼ in.,1929. Mr. and Mrs. Joachim Jean Aberbach Fund (153.1970). Digital image © The Museum of Modern Art / Licensed by SCALA / Art Resource, NY. © 2008 Artists Rights Society (ARS), New York / VG Bild-Kunst.Bonn.

When consciously chosen, colors previously perceived as drab can be surprisingly luminous. We can see this transformation in the abstract layers of Paul Klee, in which browns, tans, and grays are played against small squares of more saturated color. His paintings are a testament to the magic of neutral colors—the rich variety of color chords he has created echo the amazing range of subtle colors found in the visual world.

moving into realism

Jo Jackson, leaf study, colored pencil
Match the color of your found objects exactly, using any medium.

Georgia O'Keeffe, *Pattern of Leaves*, oil on canvas, 22 ⅛ × 18 ⅛ in., 1923. Acquired 1926. The Phillips Collection, Washington, DC
When seen as flat shapes and patterns, the colors of ordinary life become harmonies of subtle tones, an invitation to a visual meditation.

After seeing and abstracting the world, now we will add the nuances and variety of specific details, continuing our meditative approach.

EXPERIMENT: Matching Color

To further explore this subtle world of color you are seeing, choose a simple object and match the color exactly with paint or pastels. Mute the colors with gray or the complement until you arrive at that one particular color. If you paint objects arranged together, make a notan study first to establish the composition. Notice the specific detail combined with light and dark structure in Georgia O'Keeffe's *Pattern of Leaves*. The leaves have been enlarged until the shapes fill the whole canvas in a unified composition.

EXPERIMENT: Using Notan Study

As you include more of the visual details in your work, you move closer to realism. In preparation for this, first create a notan (light and dark) study of the place or objects you want to paint. Then block the notan in on a larger painting surface, using pastel or paint. Whether you are working indoors or outside, lay out the basic composition of your notan study on a toned paper or canvas of middle gray value. Block in the dark shapes and add a lighter color for the light shapes. After the light and dark composition is clear on your painting, then bring in the detail and the specific colors you are seeing. When you are held by the composition, you can give yourself over to the beauty of the visual world and linger on all its subtle nuances. Painting becomes a meditation, with each detail deepening your connection with what you are seeing.

Mila Mitchell, notan study, pen and ink, 8 × 9 in. (top); *Justin Mitchell*, oil, 45 × 45 in. (bottom)

A large painting can grow from a small notan study.

The power to bring forth images from imagination or direct observation has long captured artists, from the evocative power of the early cave paintings to the minute observations of Leonardo da Vinci and Albrecht Dürer. But this potential power can bring frustration. We can become critical, even unforgiving, when our work doesn't match what we are seeing. We long for more drawing ability and skill with the medium. Although there are many books that offer valuable techniques, few address the main challenge of realism—that in the process of matching the details of what we see, we often forget our inner forms, our own identity. Paradoxically, the most effective way to achieve a more convincing sense of the real is to reconnect with your abstract forms through the use of notan. I have found this myself when painting in the tangled redwood forest near my home; value studies help me find satisfying light and dark forms. These places call me back, year after year.

Connie Smith Siegel, value study for *Autumn Buckeye*, 6 × 9 in. (above); *Autumn Buckeye*, pastel, 16 × 19 in., 1997 (right)

Held by the light and dark of a notan study (above), we can linger on the specific details of a particular place, each detail strengthening the composition.

the lineage of value studies

The use of value studies has a long history, beginning in the Renaissance and continuing in the work of modern masters. Nineteenth-century painter Corot, especially, carried the classical power of value forward into Impressionism and contemporary art. Degas, Renoir, and even Picasso were influenced by the classic serenity and sculptural unity of Corot's figure paintings. But his passion for order was balanced by his obsession with the fleeting, even violent, aspects of nature. His direct nature studies inspired a whole generation of Impressionists who recognized his mastery of outdoor light. Corot's drawings run parallel to his landscape paintings and demonstrate his commitment to value as a primary expression for the changing forms of nature.

ABOVE: Jean-Baptiste-Camille Corot (1796–1875) *Environs de Rome*, etching, 1866. Fine Arts Museums of San Francisco, Achenbach Foundation for Graphic Arts, 1963.30.2923.

Corot's drawings were more than studies, but a full connection with nature. He wrote, "Drawing is the artist's intimate side," appreciating this opportunity for experimentation and personal expression.

RIGHT: Jean-Baptiste Camille Corot (1796–1875), *Woman with a Pearl*, oil on canvas, 28 × 22 in., 1868–1870, RF 2040. Photo credit: Réunion de Musées Nationaux / Art Resource, NY. Louvre, Paris, France.

Corot combines a mastery of shading with structural form in this portrait, strongly reminiscent of Leonardo da Vinci's *Mona Lisa*. His painting carries forward the limited color range of the old masters—but the browns and blacks played against the white shirt and skin tones are resonant in their own right. Notice the abstraction in the vest, echoed in the tree trunks of the drawing (above).

In his admiration for Michelangelo and Rembrandt, François Millet provides a bridge from the formal structures of drawing and composition established in the Renaissance. Van Gogh in particular considered Millet his primary mentor and considered him, more than any other, the painter of humanity. He was deeply influenced by Millet's early paintings, with their emphasis on the daily lives of working people—the tenderness he felt for their suffering, and the dignity of their labors. As with his older contemporary, Corot, Millet's expressive use of light and dark through drawing was a foundation for his expression. Corot and Millet's light and dark shapes embody a sentiment, a potency that goes beyond aesthetics. The evocative shapes in Millet's figures anticipate the work of Expressionists such as Edvard Munch, evoking the intimate connection between people and nature.

Jean-François Millet, France, 1814–1875. *Women Drawing Water from the River*, black crayon (photo credit: Roger-Viollet Photo Agency) (right); *Washerwomen*, oil on canvas. 43.5 × 53.7 cm (17 ⅛ × 21 ⅛ in.), about 1855. Museum of Fine Arts Boston, Boston. Gift of Mrs. Martin Brimmer, 06.2422. Photograph © 2008 Museum of Fine Arts, Boston (above).

Millet's poignant twilight shapes and luminous color reflects the depth of his empathy for people and nature.

As van Gogh began his early training in art, he learned to look at the figure and nature through Millet's eyes, not only in his choice of figurative subject matter but also in the importance of drawing and value studies. Millet was van Gogh's model for learning the structure and mastery of Renaissance and seventeenth-century greats such as Michelangelo and Rembrandt. We can see the figurative orientation in van Gogh's *Tree Study*, described by him as "the convulsive, passionate clinging to the earth, and yet being half torn up by the storm." Through the sturdy connection to the earth through drawing, van Gogh could make his wild excursions into brilliant color, held by the stabilizing force of value. The enduring structure of light and dark can support our work as well. No matter how detailed or abstract the final result, the simplicity of the drawing process connects us all—from the Renaissance to present, hand meeting paper with crayon, chalk, and pen and ink—creating order from the visual world.

I would very much like to hold my tongue for ten years and do nothing but studies.

Vincent van Gogh

Vincent van Gogh (1853–1890), *Tree Roots in Sandy Soil*, chalk on paper, 49 × 68.5 cm, 1882. Collection Kröller-Müller Museum, Otterlo, The Netherlands
Influenced by Rembrandt and Millet, the value structure of van Gogh's early work not only connected him to the forms of nature but also supported the intensity of his later paintings.

As he explored Impressionist color, the flat color innovations of Gauguin, and the abstraction of Japanese prints, van Gogh discovered that color could have its own laws and meanings, regardless of the true colors of the subject matter. But even as he was later liberated from the more restrictive tones of gray, brown, and black of his early paintings, this earlier work provided a foundation for his later, more vibrant work. No matter how brilliant, his landscapes and portraits were always defined by value, and he continued to make preliminary drawings for most of his paintings. In *The Sower* (below), Van Gogh builds on Millet's use of value but with a full color expression that mirrors his own personal intensity. Van Gogh had finally found "color which is not a realistic "trompe l'oel", but a color that suggests one sort of emotion, a passionate temperament." His innovative combination of shape and color deeply influenced the German Expressionists and Fauve painters.

Vincent van Gogh (1853–1890), *The Sower*, oil on canvas, 64.2 × 80.3 cm, circa 17–28 June 1888. The Van Gogh Museum, The Netherlands. Art Resource, N.Y.

Van Gogh's early study of value and use of powerful black shapes supports the dramatic intensity of his blazing yellow sky and the complementary purple earth. Influenced by Japanese prints and Impressionist theories, his later paintings created a whole lineage of expressive color.

The Forms and Colors of Nature: Back to the Source

Life is in the soil. Touch it with air and light and it bursts forth like a struck match. Nothing is dead, not even a corpse. It moves into the elements when the spirit has left it, but even to the spirit's leaving there is life, boundless life, resistless and marvelous, fresh and clean, God.

Emily Carr,
Hundreds and Thousands

Although the muted tonalities of traditional realism no longer dominate painting, they can still be an affirmation of familiar objects and places. Canadian painter Emily Carr found a mystical connection with the particular forms and colors of the Pacific Northwest. Although she studied the Fauve innovations in France, she found her real inspiration and distinctive palette of deep greens and browns in the somber tones of the forests and wild coasts around her native Victoria. Her forms echo the rhythms of life she experienced in the spirited meeting of sea and beach, the lush undergrowth, and soaring trees. She spoke of the "moss and ferns and leaves and twigs, light and air, depth and color chattering, you must be still in order to hear and see."

Emily Carr, *Port Renfrew*, charcoal on paper, 64.4 × 50.7 cm, 1929. Collection of the Vancouver Art Gallery, Emily Carr Trust, VAG 42.3.120. Photo: Trevor Mills, Vancouver Art Gallery (above); *Wood Interior*, oil on canvas, 130.0 × 86.3 cm, 1932–1935. Collection of the Vancouver Art Gallery, Emily Carr Trust, VAG 42.3.5 Photo: Trevor Mills, Vancouver Art Gallery (right).

Like van Gogh, Carr's drawings are a means to personal style, a search for the life and mystery in nature. She carries this life into painting (right), drawing freely with thinned paint.

Even without traditional forms or the technical skills and experience needed to paint directly en plein air (outdoors), you can always connect with the forms of nature through drawing and/or simple notan studies, working indoors or out. Sita's simple notan study from nature (below left) was translated into color, which was both a flat design and, through observation, included the specific light effects and details of nature.

Painters of the Eastern tradition, perhaps more than any other, have demonstrated the beauty of neutral colors in their paintings and prints, combining a vocabulary of traditional forms with direct observation, as we can see in the painted screen of Hoitsu. His subtle colors and love of nature are echoed in Emily Carr's earthy harmonies. The dynamic composition and powerful sense of balance and movement of both paintings are based on the power of light and dark. Although very different in execution, the work of both artists reflects a common passion for life.

Sita Mulligan, notan drawing, pencil (top); forest study, oil pastel on gray paper (bottom)

Moving from notan study to color.

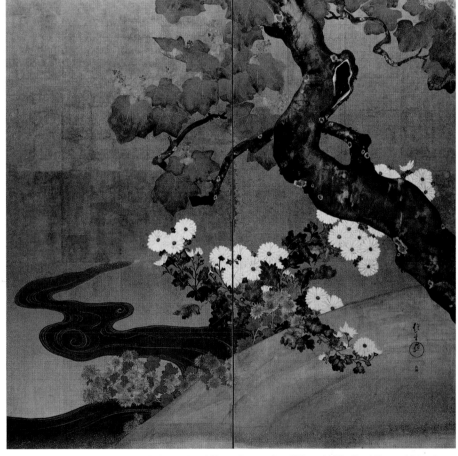

Hoitsu (Japanese, Edo period, 1761–1828), *Paulownia and Chrysanthemums*, late 1700s–early1800s. Two-fold screen, ink and color on paper, 157.5 × 158.4 cm. © The Cleveland Museum of Art, gift of the American Foundation for the Maud E. and Warren H. Corning Botanical Collection, 1964.386

Hoitsu's use of a flat gold background unifies the surface in an abstract way, and yet his tactile details of the leaves, flowers, and the modeled tree trunk have come from direct observation. Underlying all is a unified value structure, carried by the power of the dark shapes.

sensory awareness: return to the source

Like Georgia O'Keefe, whose use of notan led to her personal abstraction, Emily Carr was gifted with a sense of herself, a deep connection to an inner source that inspired her work. You have the capacity to find that inner connection as well. Begin by reviewing the first sensing experiments in value on pages 86 and 87, experiencing the practice of awareness that underlies the living spirit of the Eastern traditions.

The spontaneous movement of the brush, which reveals the breath rhythm, is not merely a technical achievement, but the immediate reflection from the painter's inmost being.

Chang Chung-yuan

EXPERIMENT: Sensing Weight

Take the time to sense your whole body, noticing any feeling states in this moment—the rhythm of breathing and the sense of your weight on the ground. Using any media, as you draw with your eyes closed, let the consciousness of weight influence your touch on the paper.

EXPERIMENT: Connecting with the World

After the sensing weight experiment, get a new sheet of paper and any drawing medium. Hold a simple object, such as a shell, and explore it with eyes closed. Then, allow your drawing hand to move on the paper with your exploration of the object, trusting where it takes you. As you give up seeing, the sense of touch can open a world of new forms. After drawing with your eyes closed, draw the object with eyes open, still allowing the sense of touch to influence the drawing.

In this closed-eye drawing (left), Jan Gross has become aware of her back. The lines and shapes reflect an inner map of consciousness, rising from the weight below. My drawing (above) was made from touching a shell, following the contours with my eyes closed. Notice the parallel rhythms in the Baiitsu painting (opposite).

ABOVE: After touching and drawing the leaf with eyes closed (top), Liana Kornfield drew it with eyes open (bottom), letting the fluid movement from the sense of touching influence the drawing. If the object is at a distance, you might also move with what you see, letting its life force influence your own.

LEFT: Yamamoto Baiitsu (Japanese 1783–1856, Edo period), *White Prunus*, hanging scroll, ink on silk, 68 × 31 in., 1834. © The Cleveland Museum of Art, Mr. and Mrs. William H. Marlatt Fund (1975.930)

Weight, touching, and movement create a living tree. Notice the sense of movement in the painting, rising exuberantly from the heavy rock.

a visual meditation

Linda Larsen, *Tomales Cypress*, drawing, oil pastel.
14 × 17 in., 2004

This drawing, done quickly on location,
demonstrates the personal touch and
movement inspired by cypress trees on
a foggy day.

We have explored the way in which drawing in light and dark can express the vital presence inherent in our sense of touching, weight, and movement. These nonvisual sensations are the inner source of both notan and meditation practice. We can see this vital presence in Linda Larsen's *Cypress* drawing (below). The spirited stroke and excitement of discovery expressed in the drawing was the inspiration for the oil painting of the same subject (opposite) and supported the painting's subtle color. This subtlety can be a visual meditation in its own right, expressing a deep peace we feel in natural places.

For Itten, this quiet and restful effect is inherent in the contrast of saturation. His mixing exercises play colors against related grays, echoing the subtle magic of Klee's checkerboard squares. The abstraction of the squares can become a visual meditation on the provocative effects of neutral colors. But the meditative effect of neutrals can come through representation as well, as we can see in the quiet grays and greens in the *Cypress* painting.

EXPERIMENT: Seeing the World

To experience the perceptual source of this subtle color, review the experiments presented earlier on seeing and matching color (see page 108). Take the time to rest your eyes, and then let them come to rest on colors in your immediate environment. See the colors as if for the first time, just for their own sake. Begin with something close—a stone, or a piece of bark, and then if you are interested, look at something further away. Make a drawing diagram of what you have seen, and if you have time, match the color closely in paint or drawing media.

This kind of meditative seeing underlies the range of browns, tans, and whites of artists such as Wyeth, Vuillard, and Morandi, who only painted places they knew and loved. The luminous small studies of artists who painted the American West, such as Frederic Church, Albert Bierstadt, and Thomas Hill, demonstrate the meditative power of this subtle color range as well. Their passion for discovery and observation of nature goes far beyond conventional realism, into the tangible presence of the moment.

Linda Larsen, *Tomales Cypress*, oil/board, 14 × 20 in., 2004 (top)

All the senses are working together in Linda's oil painting (top), from the first spirited drawing to the tactile surface to the sense of space created by the subtle interaction of color. Her paper selection (above) echoes this color harmony.

Giorgio Morandi, *Still Life*, oil on canvas,
30.5 × 30.6 cm, 1962. National Galleries of
Scotland.

Morandi never tired of painting the
subtle tones of his beloved bottles,
cups, and vases. His biographer speaks
of his "natural reserve, an innate sense
of discretion, a love of solitude which
fostered a discipline of silence." His
observation of the ordinary tans, grays,
and whites we usually ignore comes
from that quiet place of contemplation,
in which the observed and the observer
become one. The presence of his
paintings reflects this quiet perception
in the moment, lovingly preserved.

Giorgio Morandi, *Still Life*, drawing, pencil,
16½ × 24 in., 1927. Morat Institute for Art.

Morandi's delicate drawing is not so
much a preliminary study but a meditation
on seeing, space and touching. As
you take the time to see this drawing,
experience the lines and spaces in your
own body. Notice any effect it might
have on your state of being. Does
it influence your quality of seeing?

The paintings of Morandi and Church reflect different creative styles, but each artist shares a common passion for the subtle colors of nature and a love of order. They both seem to be following the advice of Corot's teacher, Michallon: "Look closely and be truthful in rendering nature."

Morandi found a whole world in his beloved collection of bottles and cups, which he observed and painted over many years. Although he ventured into a few landscapes, he was loyal all his life to the subtle grays, tans, and whites he found in the objects in his small studio.

By contrast, Frederic Church traveled all over the world, compelled to discover and record natural wonders. He combined painting and drawing in his small "painted sketches", done on location, which express his passion for the beauty of the world, closely observed.

Despite these differences, in their dedicated seeing both artists discovered related color chords—whites, tans, olive browns, and a chorus of grays, perfectly tangible, yet luminous in their effect. By their passionate observations, these artists found a potent source of abstraction, a quiet, timeless world within the world, all the more powerful because it has been there all along.

Frederic Church (American, 1826–1900) *Niagara River and Falls in Snow*, brush and oil paint, graphite on paperboard, 197 × 300 mm (7 ¾ × 11 13/16 in.), March 1856. Cooper-Hewitt, National Design Museum, Smithsonian Institution. Gift of Louis P. Church, 1917–4–765–c. Photo: Matt Flynn.

Frederic Church was a pioneer of plein air painting, combining the personal touch of drawing with closely observed, subtle color. Valued now for their luminous simplicity, his small paintings, perfectly composed, functioned as notan studies for his large and famous oil paintings of exotic places.

the tangible world of media

Although the medium we use will enhance or inhibit the effect of any color contrast, it is especially important in the subtle ranges we have been exploring here.

EXPERIMENT: Exploring Media

Try some of the media used in the art in this chapter: acrylic, pastel, oil crayon, colored pencil, watercolor, and tempera, adding textures, natural pigments, or the tactile element of collage. The surface, or ground you use—paper, canvas, wood, or metal—will affect the media, as well. If a specific medium or combination attracts you, then go more deeply into it, but for now forget the rules and just explore.

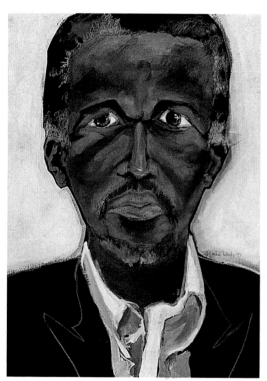

Jackie Kirk, *Ben*, from the *Face of AIDS Series*, acrylic on black paper, 22 × 30 in., 1994

The immediacy of acrylic and crayon captures the essence of a person.

Georges Braque (1882–1963), *Woman with a Mandolin*, oil on canvas, 51¼ × 38¼, 1937. © ARS, NY. Mrs. Simon Guggenheim Fund (2.1948). Digital image © The Museum of Modern Art / Licensed by SCALA / Art Resource, NY. The Museum of Modern Art, NY. © 2008 Artists Rights Society (ARS), New York / ADAGP, Paris.

Braque celebrates organic shapes and the tactile beauty of everyday objects.

Contrast of saturation can bring us into the realm of the sense of touch and the sacredness of handmade objects. From impeccably designed Japanese rock gardens to the baskets, weaving, and pottery of Native Americans, the arts of everyday life are universally cherished. Influenced by native traditions, Linda Fries paints with pigments she has gathered herself from the land, often allowing the abstract shapes to evolve into landforms, found in a collage process. The small painting of pears reminds us of the intimate beauty of the world, when we take the time to see it. Whether in painting or craft, nonobjective or realistic, contrast of saturation communicates a quiet reassurance and an enduring love of the earth in all its manifestations.

ABOVE: Cooking Basket, Artist Unknown (Pomo), split sedgeroot, split winter redbud shoots, 9½ × 15 in., c. 1895. State of Calif. Dept. of Parks and Recreation. © Heyday Books.

Art moves into everyday life.

LEFT: Linda Fries, *Land 8-2000*, earth pigment/paper, 2000

Linda paints with the earth itself, finding her pigments locally.

Kathy Sullivan, *Pears*, colored pencil, 1998

Everyday objects are quietly reassuring.

simultaneous contrast

Simultaneous contrast is harder to pin down than contrast of saturation, as we move from the solid earth under our feet to often fleeting light effects. Simultaneous contrast can be hard to recognize, as it depends on the response of the eye for its mysterious effects, often unconscious in the viewer. Simultaneous contrast combines aspects of all the other contrasts, from light and dark to warm and cool, and yet its unique harmonies are very distinctive and deeply evocative. In this chapter we will come closer to understanding its visual magic and special condition of light.

Jan Gros, *Blue at the Bottom* (detail), pastel, 22 × 30 in., 2006
Jan's complex color harmonies are a metaphor for the natural world, balancing all the elements, from the glowing reds to the subtle grays.

the simultaneous vibration

Any two colors that are not precisely complementary will tend to shift the other towards its own complement . . . both will lose their intrinsic character and move in an individual field or action of an unreal kind, as if in a new dimension.

Johannes Itten, *The Art of Color*

The same neutral gray turns blue-green on orange paper and orange-tan on blue paper.

In this color chord and pastel improvisation by Leila Johnson, the simultaneous colors of air and water are shimmery, with a subtle presence of earth.

Itten's description of simultaneous contrast, "as if in a new dimension," may sound more like science fiction than color theory, but his words clearly distinguish simultaneous contrast from the more stable contrast of saturation. Contrast of saturation plays a little bit of color against a lot of neutrals. Simultaneous contrast plays a small amount of neutrals against a lot of color, creating a vibration closer to the shimmery quality of warm and cool.

EXPERIMENT: Seeing the Effect of Simultaneous Contrast

You can see the vibration of simultaneous contrast in the example (left) in which a small piece of gray paper was centered on a larger square of red-orange. As you look at the red-orange your eye will tire, and to balance itself, will simultaneously supply the complement, making the gray square in the middle tend toward blue-green. When you try the same experiment, with the blue-green paper (center left), this same gray will turn tan-orange against blue. To experience this balancing action in another way, stare intently at the square of orange, then close your eyes or look at white. The afterimage will be blue-green, the complement of orange. In all three experiments, when the cones in your eyes that perceive a color became tired, they spontaneously generated the opposite, balancing color. Try this afterimage experiment with any strong color.

This mysterious process of the eye balancing itself occurs in the other contrasts but becomes predominant in the simultaneous contrast, whose "changeable oscillations [create] a constantly shifting state of unknowing" (Itten). We have already seen the spontaneous emergence of this quality in the tentative rondo movement of the Beethoven sonata described on page 60 that seems to be asking a question. This uncertainty in itself points to a quality inherent in the element of air.

EXPERIMENT: Evoking Air and Water

To evoke the element of air, close your eyes and focus on it, feeling any sensation inside, noticing any color or colors that spontaneously come to you. These colors could arise from your immediate sensations, or be associated with an occasion or place. Pick a color chord for this element and let a drawing grow from it. Use a colored drawing paper that is resonant with the feeling. Try this same experiment with the element of water.

Linda Larsen, *Indian Tree*, oil, 12 × 16 in., 2000 (below)

A small amount of subtle warm tones becomes more orange against blue (above). The simultaneous glow in the painting was originally inspired by a specific light condition—California hills near sunset.

Although your response may be different, the evocation of air often brings forth pink, light blue, or turquoise, played against a few grays and tans. These colors have a shimmery quality inherent in the warm and cool contrast, but with a subtle presence of earth. The element of water can evoke blues and greens, and purples, often muted or played against neutral colors. The elements of air and water come together in simultaneous glow in the painting of a twilight hill (*Indian Tree*, below) by Linda Larsen. This simultaneous effect emerged naturally from a specific light condition, but creating it objectively in the studio can be more elusive, like catching a trout with your hands.

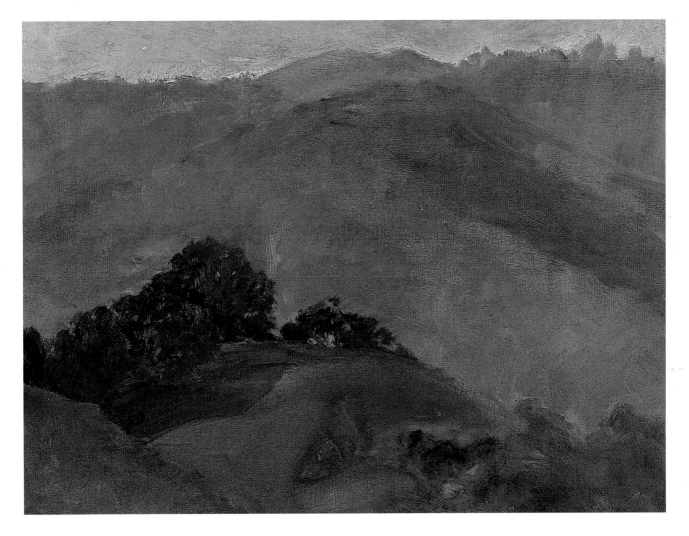

working on a colored background

For any given color the eye simultaneously requires the complementary color and generates it spontaneously if it is not already present.

Johannes Itten, *The Art of Color*

Working on a colored background can be helpful in exploring the elusive simultaneous contrast. A colored background lets you start with something that already has an evocative power.

EXPERIMENT: Working on a Colored Background

Choose a sheet of colored paper, and take some time to see it, noticing your inner responses. Let the color enter you like a sound, allowing it to resonate inside. If the color you are seeing evokes something in your life, allow that as well.

When you have a sense of the colored paper asking for something, put down a color with pastel or paint. Put another in response, letting one color follow another until the composition feels complete, leaving as much of the background as you like.

Connie Smith Siegel, improvisation on red paper (left); improvisation on blue paper (right)
The same gray turns blue-green on red and yellow ochre on blue. This simultaneous magic depends on a strong background color. The original lines in these drawings began with closed eyes, filling in the color later with eyes open.

When you see the work afterward, notice ways in which the colors (especially grays) have been influenced by the background. Try working with another colored background, feeling it inside, and letting it influence your journey. Each hue on the color wheel can take you on a whole new adventure.

To explore these reactions more objectively, put small strokes of gray crayon or paint (several tones) on different colored backgrounds. Watch the grays shift into the complement of the background, becoming stronger when the color and the gray are the same value. The simultaneous magic in the very first strokes will often diminish if the background color is covered up. Bringing back the background color will restore the magic. Seeing these subtle color changes may be challenging at first, like looking for constellations in the sky, but eventually your eye will adjust to the subtle distinctions.

Audrey Wallace Taylor, improvisation on yellow (left); Ann Faught, improvisation on yellow, *Mango* (top right); Diane Muhic, improvisation on yellow, *Iris* (bottom right)

Various reactions to the yellow background reveal differences between people. Audrey landed in simultaneous contrast, preserving the yellow background, adding just a little light gray (left). Diane covered the yellow with the purple complement (bottom right). Ann focused on light and dark (top right).

a special condition of light

Barbara Dose, *Butterfly Light*, pastel on orange paper
A reassuring memory from early childhood.

Although the colored background in itself may evoke your life experiences, you can consciously invite them, as well. These experiences can bring forward a rich vocabulary of forms and colors.

EXPERIMENT: A Special Condition of Light

Close your eyes and become aware of the present moment. Then invite into your consciousness a special condition of light. It could be something in the past or in the immediate present; it could be a place, relationship, or event. Feel this special condition of light in your body, noticing the particular quality it has and any color or colors that come to you. Then pick the color chord from the pile and find the pastels or crayons that match. Before you start drawing, give some attention to the color of the paper you are using, choosing white only if it fits the quality of light. As you work with the color on the paper, allow any development, no matter what it is. Follow your impulse. As with the other experiments, your work could include images, but it doesn't need to.

A special condition of light can evoke various places, in different seasons, and at different times of day. The condition of light can come from a memory of a personal encounter or, going within, a sense of inner light. Many of the color chords and drawings that can come from this experiment are permeated by the glow of one color, with grays, tans, and other neutrals vibrating against it. Often the forms are not delineated sharply but blend

Barbara Salisbury, *Evocation of Pond Light* (above); Kathryn De Lazlo, *Evocation of Young Daughter, Claire* (right)
A special condition of light can evoke places, people, and a sense of light from inside.

into one another, in shimmering warm and cool contrast. This is not the archetypal light of cosmic splendor, however, but light that has been conditioned by very tangible, unpredictable qualities we find on earth. Although everyone will have his or her own creative responses to the experiment below, there are always some simultaneous color chords that emerge naturally among the group of people doing the experiment.

EXPERIMENT: Colored Backgrounds with a Subject

We have explored the potential of colored backgrounds to inspire abstract improvisations and to support our evocations and memories. Now we will let the condition of light inherent in each color bring unexpected magic to what you are seeing and to echo the feeling of the subject. Try working on strongly colored paper (such as red) as you draw or paint directly from still life, figure, or landscape, noticing the effect it has on your work. After experimenting with red, notice the two works on this page, which are permeated with this color. Neutral tones have created color vibration without disturbing the particular identity of the red. The red can interact within itself (instead of its real complement), preserving its essential mood. Try working with other colored grounds as well, feeling the distinctive quality of each of the colors on the color wheel and how they influence your work.

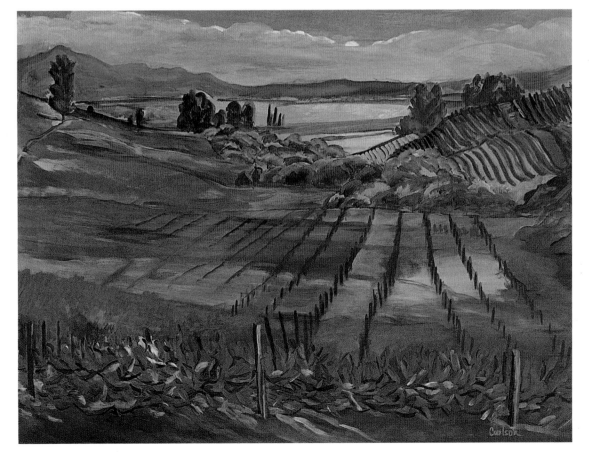

Kay Carlson, *Moon over Buena Vista*, oil. 40 × 50 in., 1998 (left); Helen Redman, *Katy*, mixed media/colored paper, 30 × 22 in., 1996 (above)

A red ground expresses the magic of autumn grapevines (left) and can also evoke the character of a person (above).

Rosie Echelmeir, *Weeping Cherry*, pastel

The value structure, established earlier in a notan drawing, supports the elusive color of pink blossoms.

Connie Smith Siegel, value study for *Desert Bush in Late Afternoon*, pencil (right); *Desert Bush in Late Afternoon, Anza Borrego Desert State Park*, oil, 10 × 23½ in., 1993 (below)

Even though sketchy, this quick gesture notan set the composition for a direct painting.

Simultaneous Contrast in Nature

As you draw and paint the forms and colors you are seeing in nature, certain light conditions can lead you naturally into simultaneous vibration. Every April a weeping cherry comes into bloom in my backyard, sending showers of pink blossoms into the air. As students pick the color chord for a blooming tree, many move into the simultaneous colors related to air. For those who want to paint the tree directly, I suggest making a value study, or notan, and then choosing a toned paper appropriate to the feeling of the color chord. The value study is especially important for those painting on location. As I was painting in the desert several years ago, I wrote to a friend about this agonizing need for compositional structure:

Yesterday I made a composition virtually out of nothing: a few shadow tones of a wash, a totally formless tree with little pink blossoms, and the lengthening shadow it made on the pink sand, with tender purple mountains in the distance. Composing this luminous color puts me to the test. The painting must have a certain light and dark contrast, but nothing too strong or obvious. It is like keeping a small fragile flame going—at any moment, with any stroke, it could disappear back into nothing.

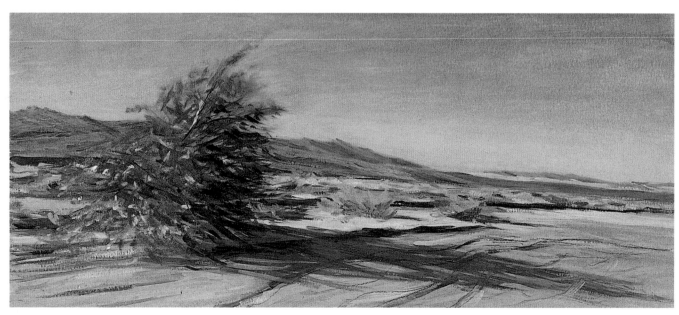

Making a notan study before painting may seem an unnecessary imposition, like a chaperone at a teenager's birthday party. But if you work from the dusty luminosity of the desert, the hills in fading light, or the silvery, simultaneous vibrations of seashores, value structure creates a container for the iridescent, fragile beauty we see in the world. Finding this structure will be different for everyone. I made a quick movement study in the desert (opposite). In contrast, Linda's studies involve a searching process through three drawings (below).

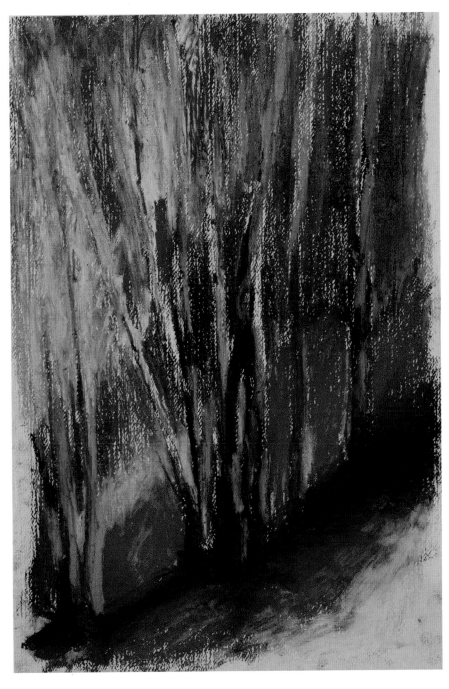

Linda Larsen, first studies for *Trees in Devil's Gulch*, oil crayon, 3 × 5 in., 1999 (above); *Trees in Devil's Gulch*, oil crayon, 17 × 14 in., 1999 (right)

From tentative beginnings, the composition evolves. The final painting integrates all the versions.

Tonalism: A Special Condition of Light

We see a subtle but firm composition in nineteenth-century artists such as Turner and Whistler, whose luminous paintings influenced a group of painters called Tonalists. Their work parallels our special condition of light experiment: diffuse forms emerging from a soft, palpable, all-enveloping atmosphere, with a prevalence of one color. The preferred times of day for these artists were dawn, early morning, twilight, or evening.

Joseph Mallord William Turner (1775–1851). *St. Florent le Viel*, watercolor and gouache on paper, support: 144 × 193 mm, ca. 1826–1828. Bequeathed by the artist 1856. Photo credit: Tate, London / Art Resource, NY. Tate Gallery, London.

The slightest suggestion of light tan in Turner's watercolor, painted directly on location, becomes iridescent against the blue paper.

Sydney Laurence, *Mt. Susitna, Cook Inlet, Alaska*, oil on canvas, 13 × 26 in. Gift of Dr. and Mrs. John I. Weston. University of Alaska Museum of the North. Photographer: Barry McWayne.

Dark shapes in Lawrence's sunset (below) turn purple against yellow-orange.

This tradition has been continued and expanded by contemporary landscape artist Wolf Kahn, whose early paintings as a student of Hans Hoffman displayed contrast of hue and warm-cool palettes. Influenced by the particular light and land of Vermont and Connecticut, his work evolved into a predominantly simultaneous palette. Often initiated by pastel studies painted directly on location and later completed in the studio, his paintings communicate the transcendental magic that glows from light meeting the substance of earth.

I want each painting to reflect a sense that I have been there, in that spot, a specific spot where I have had a specific kind of experience.
Wolf Kahn

Wolf Kahn, *Riverbend I*, oil, 38 × 41 in., 1978. Art © Wolf Kahn / Licensed by VAGA, New York, N.Y.
The simultaneous glow in Kahn's painting is a synthesis of the vibrant hues of his early work with the austere and textured neutrals he found in nature. In integrating fire and earth his paintings achieve a unique presence, a special condition of light—transcendent, yet very real.

integrating the elements

Pat Maloney, *Mama y Floras*, oil, 36 × 20 in.
Intense complements express a person.

Pat Maloney, *Drawing Improvisation*, pen and ink
12 × 17 in.
Pat has filled many drawing notebooks, accessing an inexhaustible source of forms.

We have explored the Itten contrasts in the context of the Western tradition of art, often working in the context of landscape painting, watching the evolution of painting from the light and dark of the old masters to the vibrant contrast of warm and cool and hue of the Impressionists and Fauve revolutions. This history is a rich source of visual inspiration. But, as we have seen in earlier sensing experiments, these expressive modes can be internally generated as well, without reference to history. This expression comes primarily from inner sensation and is deeply connected with the timeless dream and metaphoric world of shamans and indigenous people.

This inner connection can be seen in the work of Pat Maloney, whose drawings and paintings follow his own inner evolution and reveal his internal changes over time. For decades, he has explored the world of light and dark through a continuous practice of drawing, and he has fully expressed the intensity of complements and warm and cool. In *Original Dancer*, Maloney's synthesis of these two polarities has created a vibrant example of simultaneous contrast. The different elemental forces of earth, fire, air, and water have been integrated into a new creation, pulsing with life, mysteriously powered by the gray-purple in the background. The vibrant hue or warm/cool vibrations have been tempered by this gray, inviting the viewer to participate in the mysterious shimmer. Itten was especially fascinated by the simultaneous effect, which he called rubescence, and used it frequently in his own work.

Earlier in the book, we saw the potentially conflicting forces of light/dark and intense color in van Gogh's work come together in a powerful interaction of dramatic complements. We can see this vibrant interaction in the earlier painting, *Mama y Floras* (top left). But the powerful pull toward integration inherent in simultaneous contrast has created a new synthesis. In *Original Dancer* (opposite), Pat Maloney has reconciled the opposite forces of color and value in a different way.

Pat Maloney, *Drawing Series*, graphite, 30 × 40 in.
In contrast to the figure painting, this powerful form balances light and dark.

His recent paintings and drawings reflect an alternate reality, found also in Paul Klee, which taps into the deep archetypal forms generated for centuries by indigenous people, from the Australian aborigines, to the Huichal Indians, as far back as the cave paintings of Lascaux. The forms and colors come from a collective unconscious, deeply related to these native artists, and yet very particular to him. The original source, which Pat describes as a "full-body seeing," comes as much from the sense of touch and weight as from seeing. The images here describe a healing journey, honoring the subconscious—aware of contemporary art but connected to our primal beginnings.

Pat Maloney, *Original Dancer*, acrylic, 4 × 5 ft.

Although beginning with a sketch, once the painting has started, it generates its own colors and shapes, pulsing with life.

integrating the contrasts

By combining aspects of light and dark contrast with warm and cool, simultaneous contrast becomes the great integrator of all the contrasts, bringing together forces that seem to be irreconcilable. Finding and maintaining this delicate balance of forces is exciting but often challenging. Because color vibration is largely "created" by the eye, it requires constant attention to keep it alive, both in creating and in viewing. The viewer must see the work in a meditative way, giving time for the eye to create its simultaneous vibrations. These elusive vibrations can be disturbed by the wrong color of mat and frame, inadequate lighting, or even the wrong wall color. Georgia O'Keeffe, understanding these visual dynamics, sometimes had whole museum halls repainted to enhance her subtle paintings.

Connie Smith Siegel, *Hills and Clouds, San Geronimo Valley*, pastel, 22 × 30 in., 2002

The wild and sweeping movement of the clouds on a spring afternoon originally inspired this landscape. But underlying this movement and the changing play of light and shadow is a solid value structure, a series of shapes and spatial relationships continuing through field, hills, and sky.

Audrey Wallace Taylor, *Gaia Turnin' Series: Sun*, oil, 8 × 7 ft., 1998

Drawn many years before, Audrey's sensing drawing (below) presages the expansive universe of her large painting. She has integrated all the elements in this large canvas of *Earth*, as seen from outer space (left).

Although the requirements for simultaneous contrast are challenging, they are also the source of its magic, whether you are working abstractly, from the tangibility of still life, the fleeting light on hills, or the whole planet seen from outer space. In bringing together light and dark composition and color interaction, we are replicating the constant balancing of the earth itself among all of its different elements— earth, water, air, and fire (which contains the quality of light). When these forces are integrated, a miracle is born: the reality of light shining through matter. In the still, timeless state of the present moment, the beauty and truth of the visible world become both luminous and tangible. The transcendent radiance of the warm and cool contrast comes to earth.

Audrey Wallace Taylor, improvisation, charcoal, 18 × 24 in.

the power of space

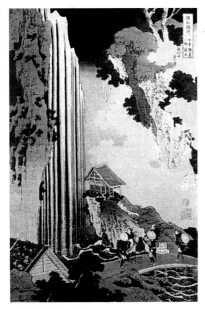

Hokusai, *Ono Waterfall on the Kiso Rd.*, color woodblock print, 37.4 × 25.6 cm, 1834–1835, private collection.

Although more than a century apart, both Hokusai and Diebenkorn use space in a dynamic way, expressing the unseen force of gravity. Through this balancing force, Hokusai has converted a complicated scene into a unity of interlocking planes.

One's sense of rightness involves
absolutely the whole person and
hopefully others in some basic sense.
Richard Diebenkorn

Even before lighting and framing, the delicate luminosity of the simultaneous contrast depends on compositional unity, and the balance of weight and space in notan studies. But instead of characteristic shapes, the emphasis in simultaneous contrast often depends more on the elusive presence of the space between the shapes.

EXPERIMENT: Reviewing Spatial Composition

To explore composition from this perspective, review the spatial composition experiment on page 101, beginning with a sense of your inner space and extending this awareness to the space of the paper. After drawing from this spatial awareness, look at the space you see in the world around you. As you draw, perhaps using gray paper with white and black media (see pages 164–165), you may rediscover the unifying power of the hidden spaces between objects. Notice the use of negative space in Hokusai's woodblock print, unifying a complicated scene. Seeing and drawing this space can become a visual meditation, inviting the use of color in mysterious ways. The language of spatial abstraction is exceptionally clear in Richard Diebenkorn's work, from the figurative work (see page 100) we saw earlier to his later abstract *Ocean Park* paintings (opposite), which distilled the light of his ocean environment into luminous planes of color.

Contrast of Extension

The luminous magic of Diebenkorns's color is also due to the distribution of space that defines Itten's last category, contrast of extension—the contrast between much and little, great and small. A small amount of a color becomes more intense when played against a larger amount of another. This contrast has no intrinsic elemental quality in itself but can account for provocative color effects, especially in the subtle contrasts.

For example, in Diebenkorn's *Ocean Park #54* (opposite), small shapes of yellow, pink, and deep blue at the top vibrate mysteriously against the large expanse of very light purple. Contrast of extension was demonstrated earlier in this chapter when we saw the same sliver of gray change against different backgrounds (see page 130.) This proportional difference is necessary to create the vibrancy in the simultaneous contrast and defines contrast of saturation as well—which plays a little color against a lot of neutrals. For example, in the Hokusai print (above), small pieces of tan-orange stand out against the different grays. Earlier in the book we saw how the small reds in Braque's painting (see page 124) stand out against blacks and khaki colors. The small rainbow in Kurt Schwitters' collage (see page 30) glows against the subtle grays. A small vibrant orange glows against browns and grays in Paul Klee's *Fire in the Evening* (see page 109), and a few red-orange squares punctuate Johannes Itten's work as well (see page 157). Look through the book again to find these and other examples of the hidden but vital contrast of extension, and experiment with these visual effects yourself.

Richard Diebenkorn, *Ocean Park #54*, oil on canvas, 100 × 81 in. (254 cm × 205.74 cm), 1972. San Francisco Museum of Modern Art. Gift of Friends of Gerald Nordland. © Estate of Richard Diebenkorn.

The spacious austerity of Diebenkorn's large oil evokes the special radiance of ocean light. Almost imperceptible lines of gravity, horizontal and vertical, support the quiet interplay of simultaneous complements—yellow and violet, and blue violet against yellow orange.

compositional unity and elemental archetypes

Each of the different color contrasts has its own visual and psychological effect, reflecting different emotional and elemental qualities. After exploring these contrasts one at a time, you may discover the ones you feel most at home with and might want to explore those more profoundly. As you go deeper, you will find that the elemental quality of each contrast carries a whole value system, a way of finding meaning in the world. In this chapter we will review these value systems, as well as provide examples of people who exemplify them.

Connie Smith Siegel, *Afternoon Oak*, pastel 22 × 30 in., 2007
The late afternoon light on and around a massive oak tree is captured with warm and cool strokes.

the elemental source of composition

Connie Smith Siegel, *Fall Reflections*, acrylic/crayon, 24 × 12 in., 1989

Hidden grays around the red create a simultaneous glow (below). Yellow willows play against a blue-gray hill (above).

Although contrast of extension can enhance other contrasts, the real elemental language of color is carried by the six contrasts we studied in the previous chapters. After exploring these contrasts, one at a time, you may have discovered one or more you feel most at home with. After taking the time to see your work as a whole so far, you might recognize the experiments with which you felt most connected and can explore these expressive modes more in depth. Artists achieve mastery by working within one of these modes. Successful paintings resonate with a consistent primal message, and when this message isn't clear, the painting lacks unity. Two or more strong qualities competing for dominance will create a mixed message, much like hearing two radio stations at once. Each contrast, or elemental archetype, has particular requirements—what unifies one will often destroy another.

For example, the strong value contrast essential for muted tones will destroy the shimmery light of warm and cool. The intensity of color needed for contrast of hue and warm and cool can disturb the light and dark contrast and the nuances of the subtle contrasts. In this way, each contrast is a kind of elemental ecosystem, with implacable requirements for survival. For a drawing or painting to be visually effective, these requirements must be met.

Return to the Inner Source

Keeping track of these requirements may seem daunting, but your intuition will always find the right balance of forces when you choose a color chord; it's as uncomplicated as that. The simplicity of the colored papers can clarify the elemental qualities at the beginning and/or help you return to the original feeling. When we

Connie Smith Siegel, *Sonoma Vines, November*, pastel, 12 × 30 in., 2003

stick to our initial impulse in this way, and find a medium that matches the elemental feeling quality, our pigments, canvas, and paper are transformed into a living presence. They become a window into the raw and vibrant energy of the cosmic world, and we expand into a larger reality as if in the presence of mountains or ocean. It is this reality, this primal power, that underlies mastery in art, from the brooding depth of the old masters, to the shimmery layers of the Impressionists, obsessed with sunlight, to the thick strokes and fiery colors of the Fauves and German Expressionists, rebelling against the dark glazes of the old masters.

Each of these elemental expressions carries with it an entire value system, a way of finding meaningful survival in the world. We see this larger meaning not only in individual artists but in whole cultures as well, from the transcendent radiance of the great cathedrals to the ancestral patterns and subtle colors of Native American baskets and pottery, to the brilliant colors of thanka paintings and ceremonial objects of Tibetan Buddhism. Each creates a persuasive reality that can expand and transform our world.

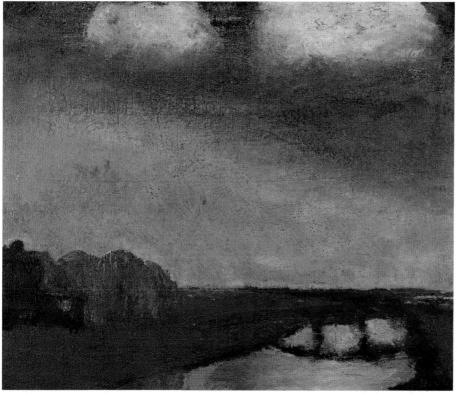

Emil Nolde, *Frisian Farm on a Canal*, oil, 25⅝ × 34½ in., 1935. © The Ada and Emil Nolde Foundation, Seebüll, Germany.
Small white clouds and yellow haystacks glow against blue sky and river. Nolde's color combines the audacious intensity and confidence of a child with a deep understanding of structure gained from light and dark studies of master painters, such as Goya, we have seen earlier.

I believe in the sun and the moon, for I feel their influence. I believe there is a fire blazing in the bowels of the earth and that it influences us mortals.
Emile Nolde, 1895

personal characteristics of the itten contrasts

The different value systems in the Itten color contrasts can reflect personal characteristics that parallel elemental qualities of the sun signs of the zodiac.

Contrast of Hue Characteristics

I have observed that artists who favor the fiery contrast of hue tend to be more independent. They do not like to follow light and dark studies but prefer to let their intense color create its own composition—like Kandinsky, whose brilliant improvisations pioneered nonobjective painting, and Helen Redman, who has pushed the limits of color in her portraits, as in *The Change* (left). Both artists have been creative leaders, and they each started their own foundations or art movements rather than work for (and follow) others. Contrast-of-hue people often have a strong personal presence—like the sun itself—and are often outgoing, embracing all aspects of the world.

Contrast of Warm and Cool Characteristics

By contrast, people drawn to the iridescent colors of warm and cool contrast tend to be more introspective and focused on the world of light. They can work effectively with astrology and psychic counseling, trusting unseen reality as much as facts and figures. In solving problems,

Helen Redman, *The Change*, Self Portrait acrylic, 48 × 30, 1993 (above); Art Holman, *Nebula II*, oil, 44 × 64 in., #400, 1982 (right)

Helen Redman's personal presence (above) radiates outward. Art Holman combines his observations of light in nature and the universe with a sense of inner light (right).

A Black Geranium
O, sweet geranium!
Hung high
like a heavy prize
burned black
'gainst the sun's lapsed
meridian.
Mila Mitchell

they more often look for spiritual, mystical guidelines, trusting the power of intuition and imagination rather than more pragmatic solutions. For example, Art Holman's spiritual connections are sustained by intuitive studies and the mystical traditions of Egypt and Scotland.

Contrast of Light and Dark Characteristics

People with a strong affinity for contrast of light and dark tend to trust more pragmatic solutions to problems. These down-to-earth solutions can come from cultural or family traditions, in the same way that compositional form through value has been carried by generations of painters such as Rembrandt and Corot. Structural integrity and honesty are important in both painting and in life.

Through the simplicity of value contrast, Mila Mitchell found meaning and order in a world of emotional turmoil. Finding the balance of light and dark in her still life drawing *A Black Geranium* (above) was centering, giving stability to her life. This balance is not so much a geometric equation as a passionate prayer to earth. The compelling need for clarity becomes softer in her later pastel of a child (*Child in Light*, right), with larger strokes and subtle color. The dark shapes of modulated grays surrounding the strong patch of light in the center support the delicate figure, vulnerable, yet self-assured. The small white collar, red stockings, and the constellation of pink and purple dots accent the muted colors—a masterful expression of contrast of saturation.

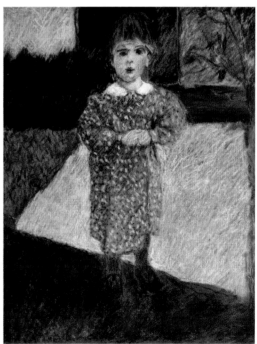

Mila Mitchell, *A Black Geranium*, pen/ink, 22 × 29 in., 1976 (top); *Child in Light*, pastel, 24 × 20 in., 1990 (above)

Emotion is contained in the balanced security of light and dark shapes (top). Dark areas support the delicate color of a painting done many years later (above).

Contrast of Saturation Characteristics

Those people who are drawn to contrast of saturation very often share the personal characteristics of light and dark, identifying closely with specific places, immediate family, and friends. Vuillard found a world in his mother's small apartments; Morandi never tired of his beloved bottles, cups, and vases; and Richard Conklin painted his mountain home of Leadville, Colorado.

Richard Conklin: Contrast of Saturation

This love of the mountains and the stark wilderness of high mountains was an integral part of Conklin's life and work. He was direct in his communication, with a strong need for loyalty and honesty in his relationships. His work was pared down to the essentials as well—flat planes of color held by the simplicity of light and dark studies. As an undergraduate student influenced by the bravura brushwork of Abstract Expressionism, his paintings seemed too simple to me. But after a few years of struggling with color, I began to see the beauty of his flat planes. The subtle earth tones in his still life paintings showed without words the expressive power of colors when valued in themselves. His work revealed the bones of painting, and from this solid foundation I found my own sense of form.

For decades I have shown students the small value studies, wordless demonstrations of structural integrity, found in his studio after his untimely death in 1961. It was inspiring to witness the evolution of this integrity—from the classical simplicity of his earlier paintings to the spatial presence of his later landscapes, displaying the brooding power of moonlit peaks, and the luminous white of distant mountains against a triumphant blue sky.

Richard Conklin, still life study, pencil, 2 × 3 in. (above); *Love Even This*, oil, 24 × 30 in., 1956 (right)

The tiny study (above) created the structure for the still life painting. This homage to order plays a few dark blues against a close harmony of browns.

Richard Conklin, value study, *Winter Morning*, pencil, 2 × 3 in., 1959 (above); *Winter Morning, Leadville, Colorado*, oil, 30 × 40 in., 1959 (right)

The light and dark of the study (above) underlies the spacious landscape, creating an abstraction as well as representing a particular place. In the painting, a transcendent blue sky glows against the earthy tans and browns in the painting (right). The subtle differences in the whites create dimension and become luminous against the darker neutrals.

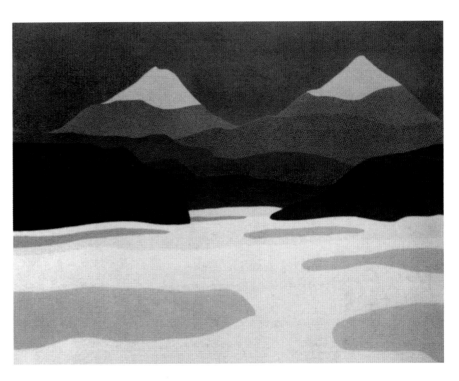

Richard Conklin, value study, *Mountains in the Moonlight*, pencil, 2 × 3 in., 1958 (above); *Mountains in the Moonlight*, oil, 30 × 40 in., 1958 (right)

Conklin used the simplicity of his small notan study (above) to find the composition for the memory of a moonlit night in the high mountains (right).

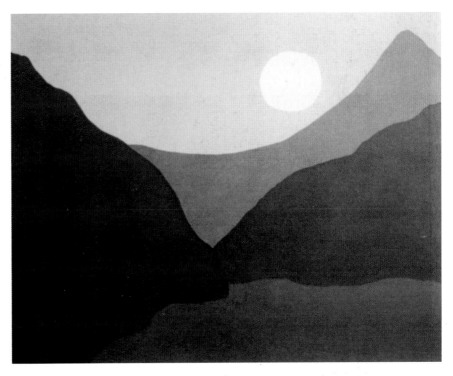

Contrast of Dramatic Complements Characteristics

The artists drawn to dramatic complements need both the full intensity of color and the power of light and dark. They are masters at balancing these strong forces, although they can sometimes be overwhelmed by them. We can see this full expression of forces in Lynnelle's *Kevin Cooper* and *Seal Moon* (below), as she combines a strong sense of value with vibrant color. Lynnelle, Jackie Kirk, and Jan Gross reflected this full intensity in their lives as they pursued active careers as artists, teachers, and mothers of large families. Van Gogh successfully combined solid form with vibrant color in his last paintings, but in his tumultuous life he was often torn between traditional values and the strength of his passions.

Lynnelle, *Kevin Cooper*, charcoal, 18 × 18 in. (above);
Seal Moon, acrylic, 48 × 54 in., 1986 (right)

The life force expressed in Lynnelle's charcoal drawing (above) is echoed in her larger painting (right), which combines strong dark shapes with the vibrant blue and its complement of orange. The archetypal forms in the painting subtly evoke a natural place.

Simultaneous Contrast Characteristics

The receptive seeing needed for simultaneous contrast has its equivalent in life. Those drawn to this subtle contrast can be receptive and empathetic, seeing and listening deeply to other people and to the environment. Like those drawn to warm and cool, they have an ability to see the larger picture, to put space and light around an issue. Because they have an affinity for contrast of value as well, they are genuine peacemakers, able to see all sides of a question. However, seeing all sides can be inconvenient when making decisions in daily life. It can lead to a loss of identity, a feeling of not belonging anywhere. But this very ambiguity can generate freedom, both in life and in painting.

The precarious balance between definite form and evanescent light in the landscapes of Turner and Wolf Kahn creates a magical space where fantasy and reality meet.

As I search for that delicate balance of elemental qualities in my own painting, the stability and clarity of value contrast can often seem at odds with the evanescent lure of color. I can be held by the dark power of forest creeks and waterfalls in winter, but in the spring the explosions of blossoms in the valleys and coast become irresistible. The fluttering aspens, brilliant against the autumn sky, have captured me in the same way. I have alternated between oil, acrylic, and pastel to meet these different light conditions. In recent years, soft pastel has met my need for depth of layering, but the paper that works for the dark forest is not as suited for vibrant color. Finding the appropriate media, while staying true to my inner necessities as I draw and paint in natural places, is constantly challenging, a continuing and vital engagement.

Connie Smith Siegel, *Winter Falls I*, pastel, 23.5 × 15.5 in., 1992
The light and dark shapes of a winter waterfall (above) contrast with the coastal landscape's shimmery interactions of water, earth, and light (below).

Connie Smith Siegel, *Slough at Kehoe I*, pastel, 12 × 30 in., 1999

The Mighty Oak: Five Different Views

The personal characteristics of the color contrasts were demonstrated in a vivid way as a group of us drew and painted an extraordinary oak tree in the hills above my house. Almost thirty-six feet in circumference, it is miracle of vitality and longevity, with the awesome presence we might feel from a rock formation, waterfall, or any other natural wonder. However, even this mighty oak was showing signs of sudden oak death, a disease that has affected many oaks.

We first responded to the tree's vulnerability, but as we worked we were struck by the vitality of its primal force. Like musicians playing from the same score, we were deeply influenced and were astonished later to find this force accentuated our own unique powers as well. These works expressed the miracle of our different viewpoints, expressed in different media. Our drawings, paintings, sculpture, photographs, and video generated a community event, which included a performance of poetry and music and a scientific lecture.

Jean Woodard, *Oak Study*, brush and ink, 20 × 17 in., 2007 (right); *Oak Improvisation*, oil pastel, 20 × 17 in., 2007 (left)

Jean used the starkness of black ink in a tactile exploration, drawing as though she were actually touching the tree (right). After this detailed study, she made a movement improvisation of the tree (left), reaching for the sky.

Veronica Buros, *Paws Sing at the Mighty Oak*, collage, 20 × 17 in., 2007 (left); Linda Larsen, *Oak*, oil, 20 × 24 in., 2007 (right)

The oak taught Linda a whole new technique of working with oils using thick paint and a palette of deep browns that matched its earthy strength (right). Veronica features her dogs in front of the oak in a colorful red collage (left).

Connie Smith Siegel, *Afternoon Oak*, pastel, 22 × 30 in., 2007

Finding the light on and around the tree accentuated Connie's use of warm and cool.

elemental balance and diversity

Suki Diamond, group healing drawing, oil crayon

Suki's drawing for a group healing expresses archetypes for earth and heaven, death and renewal.

As we discover our unique color harmonies, we become more effective, not only in art but in relationships and vocational choices. Itten demonstrated this possibility when he used subjective color chords to help art students find working materials most natural to them, from the cooler tones of metal to the warm browns related to woodworking.

But as much as we need to find our special elemental tendencies to be effective in our work and life, we also need diversity. Although we each have a base in one of the elemental modes, we have all of them within us.

Our physical and mental health depend on expressing all aspects of our nature: the solidity of earth, the fluidity of water, the openness of air, and the vitality of fire. It is the constant interaction between these divergent qualities that keeps us balanced. When we become stuck in any one element, we can lose our equilibrium, our sense of wholeness.

Barry Raybould, *Diving into Deep Water*, color selection (above); *Diving into Deep Water*, pastel improvisation (right)

In his color selection and improvisation, Barry uses a small amount of red-orange against its blue-green complement to evoke the drama and excitement of diving into deep water.

Johannes Itten, *Simultanes Leuchten öl auf Leinwand*, 70 cm × 60 cm, 1964. © 2008 Artists Rights Society (ARS), New York / ProLitteris, Zurich.

As a teacher and universalist, Itten's color system embraced all aspects of life, echoing the full spectrum of human emotion. Studying his contrasts becomes a healing journey in its own right as each elemental quality brings us more into balance. However, as an artist he preferred the hidden mysteries of the simultaneous contrast, as we can see by the subtle squares of olive grays vibrating against the more intense blues and bright red accents (contrast of extension.) The excitement of Raybould's diver (opposite) against a blue field achieves a similar effect.

Connie Smith Siegel, *Healing Series: The Fire of Anger*, oil pastel, 18 × 24 in. (top); *Healing Series: Movement Toward Earth*, oil pastel, 18 × 24 in. (center); *Healing Series: Resolution Toward Light*, oil pastel, 18 × 24 in. (bottom)

This three-part healing process moved beyond my habitual expressions into a rich diversity of forms and colors, transforming anger into earth power and then into joyous confidence.

EXPERIMENT: Balancing the Elements

To be reminded of our intrinsic need for balance, we can return to our first experiments in Sensory Awareness, drawing, and color—abstract improvisations as reflections of our changing elemental states. When expressed in a series of two or more drawings, we can witness the movement of our inner states and our inherent instinct for balance and wholeness. These improvisations often spontaneously echo events and issues in our lives, and they can be consciously used to focus on issues in our lives that have come out of balance.

Try this for yourselves. After seeing your first improvisation in color and drawing, follow the impulse of the moment with two other drawings, allowing each drawing to grow naturally from the next. If you find yourselves preoccupied with a specific issue, dilemma, or discomfort, focus on this inner sensation of your discomfort and allow this feeling to be expressed directly. After seeing and experiencing this drawing, follow it with two more drawings and/or other color choices, allowing any development, with no expectations, no judgments. While you are working, and later, when you see all of the drawings and colors together, notice any insights that come. Moving with the drawings, or writing freely from your impressions, can bring us closer to the inner source, often with unexpected recognitions.

Our study of the Itten contrasts can be helpful in recognizing and appreciating the elemental quality of your emotional states. Notice these archetypes in my Healing Series, which began with an emotional outburst of hurt and anger, expressed in the large red and green strokes of dramatic complements (top left). These explosive colors were grounded by the clarity and stability of the dark vertical and curved lines in the second drawing (center left). In the third drawing (bottom left) the circular movements prevailed, bringing luminous yellows and oranges of contrast of hue, reflecting a sense of joy and confidence.

This spirited dialogue between elemental forces brought forth a wide vocabulary of visual forms that not only created a significant change of consciousness but can be seen in the landscape as well (opposite). In this context of art and healing, a whole new dimension of the color contrasts can emerge as we see them in action, fulfilling their emotional potency. The elemental power contained in the contrasts can become a healing force for all of us, not only in art but also in our lives.

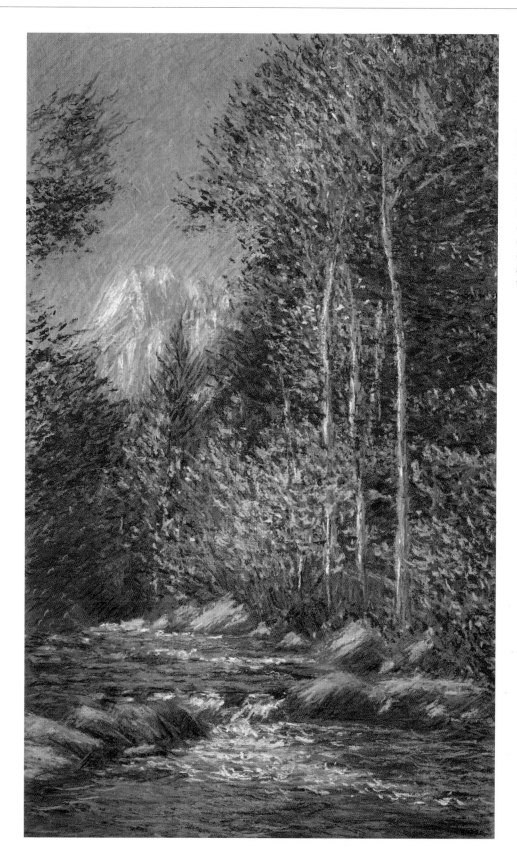

Connie Smith Siegel, *October Aspens, Lake Sabrina*, pastel, 27 ½ x17 in., 2006

Although this painting depicts a specific place, it is really the abstract elements seen in the healing process on the opposite page that carry the real message. The sense of well being expressed in the third drawing (bottom) is the inner source of my attraction to the radiance of autumn in the eastern Sierras. I am drawn there, year after year, searching for this inner light reflected in the natural world. Under the fluttering leaves is the urgency of the burning fire expressed in the first drawing (top). The dark vertical lines in the second drawing (center) are echoed in the tree trunks and the arc of rocks below, stabilizing the bright oranges and yellows.

My words are tied in one
With the great mountains,
With the great rocks,
With the great trees,
In one with my body
And my heart. . .

Yokut

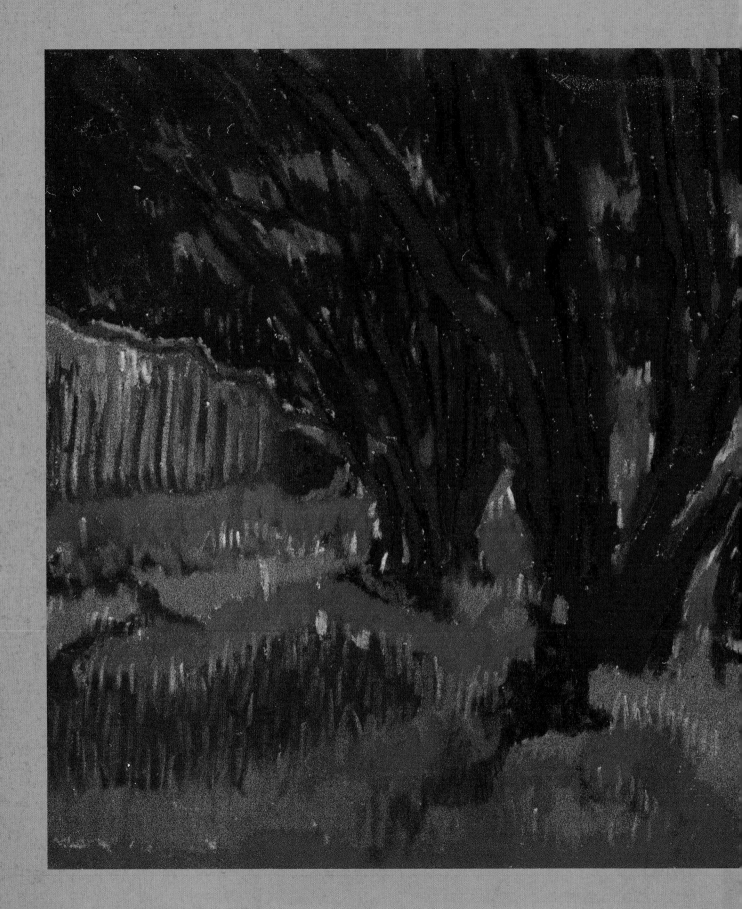

tempera and oil painting were carefully passed from master to apprentice. But in time, this very mastery inhibited individual expression, and creative rebels such as Monet and Pissarro discarded traditional methods in their passionate search for light. Their Impressionist revolution became a "technique" in its own right and opened a new world of color to artists such as Cezanne, Bonnard, and Matisse. The Impressionist use of pure color allowed van Gogh to break away from his brown glazes and to finally realize his vision of "speaking a symbolic language through color alone."

Without knowledge of your inner tendencies, specific techniques can obscure your own unique powers. There is no need to "master" any of the media described here; to find one that matches your unique sensibilities is the goal. Because this exploration is so vast, and so much information is available, we will focus our discussion on finding the fullest expression of the different color contrasts we have studied.

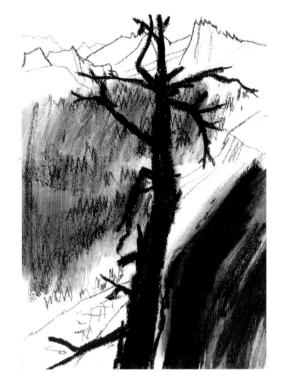

*We certainly set down a self-portrait of our own
inner feelings with everything we do,
and how much finer to have the means of expression
in harmony with these feelings.*

Arthur Dove

Connie Smith Siegel, *Mammoth Ridge* (detail), pencil, pen, Caran D'Ache, and watercolor wash on gray "TV illustration board," 7½ × 22 in. (above); Beatrice Darwin, *Mammoth Ridge*, charcoal pencil, 6 × 4 in. (top)

Individual points of view are expressed in different media. Beatrice drew a nearby tree and cliff with bold charcoal strokes on white (top), while I focused on the faraway Mammoth Ridge (above), using white crayon on gray paper to highlight the receding space and snow on distant peaks.

light and dark media

Although light and dark is a necessary combination in any color and painting medium, the simplicity of black or gray pigment on paper can most immediately reveal the particular quality of our life force, changing every minute. As we have seen with many master painters, exploration through drawing can allow you to focus on individual touch and the development of personal shapes and spaces without the distraction of color. Especially when drawing directly from the visual world, the simplicity of light and dark creates an important bridge between your inner forms and what you are seeing. Each of these media has its particular voice and can evoke different feeling qualities. Explore for yourself, in a free-form experiment, with the materials below.

Light and Dark Drawing Media

Pencils are made from graphite and have many gradations from hard (H) to soft (4B–6B). Graphite also comes in square sticks, giving the option of using the broad side as well as the edge. The softer grades are more immediately expressive on most papers.

- **CHARCOAL** is available in vine and compressed forms. There are many different kinds of charcoal. The soft, malleable vine charcoal comes from charred twigs. It varies according to the kind and size of wood used. In a summer workshop, pieces salvaged from a burned log left in a grill became like pure gold as people discovered the tactile beauty of this natural medium. For darker tones try compressed charcoal, which can range from delicate grays to dense blacks. Many brands of compressed charcoal and charcoal pencils have a numbered range from dark to light.
- A **KNEADED RUBBER ERASER** is versatile and can even be used as a drawing tool with pencil and charcoal, creating white lines in toned areas. It can absorb a lot of pigment, and after kneading it can be ready to pick up more.

LITHOGRAPH CRAYON

GENERAL'S CHARCOAL PENCIL

CHINA MARKER BOHEMIA GRAPHITE
 PENCIL

CHARCOAL FABER EBONY
PENCIL

VINE CHARCOAL

Kathy Callaway, mixed media exploration (above);
Linda Fries, charcoal improvisation, bond paper,
22 × 30 in. (right)

Kathy explored the differences between each medium (above). Linda discovered a special kind of charcoal, which matched the exuberance of her natural movement (right).

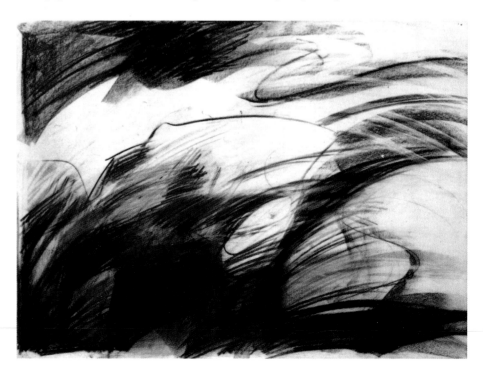

- **CRAYONS** have more wax and are generally denser than charcoal. The subtle voices of black, sepia, and white Conté crayons, made in France, are especially useful for graduated modeling; they range from hard to soft. Lithographic crayon (used in printmaking) is waxier and also ranges from hard to soft. Caran d' Ache Neocolor crayons are a colored drawing media and are described on page 166.
- **PENS** used with waterproof India ink can give a range of effects, from the delicate Cro-quill, to the larger Speedball lettering pens, which range from the smallest (C-6) to the larger (C-1). Felt tip, ballpoint, and other mechanical pens can be useful, but they are seldom archival and therefore can fade in time. Balsa wood or found sticks dipped in ink can create unpredictable effects. Handmade inks from natural materials can be exciting as well and can match the browns and subtle tones of Rembrandt and van Gogh.

Paper for Drawing Media

There is a wide range of paper for drawing media, from the less expensive newsprint and bond paper to better grades of plate (slick) and vellum (rougher) to Bristol board to the more textured charcoal papers. The better papers (rag based and archival/acid free) come in pads or single sheets. Aquabee Bristol pad, two-ply, vellum finish is a brand that can sustain longer drawings. Heavier papers used for printmaking are good for drawing as well. Commonly used brands are Arches cover, Rives BFK, Folio, and Stonehenge. Toned paper—gray, tan, black—can be useful with white Conté crayon. Canson Mi Tientes, or Crescent boards and papers, Fabriano Tiziano, and Canford are commonly available brands. Each kind of paper reacts to media in different ways.

Connie Smith Siegel, *Vernal Falls, Yosemite Valley*, pencil, Caran D'Ache and acrylic wash on green mat board

In response to the wild force of the waterfall, I first established a unified composition with a darker wash, then drew with black and white Caran D'Ache, and finally used white acrylic for the foaming water.

Lynnelle Herrick, *Pyramid Rocks*, charcoal. 22 × 30 in., 1980

Through the tactile intimacy of soft charcoal, Lynnelle draws a rock formation as if she were touching every one.

colored drawing media

Working with color can bring drawing closer to painting, expressing elemental qualities more fully. To test out different kinds and brands, try introductory samplers, available in media catalogs.

- **COLORED PENCILS** are the hardest and offer subtle, controllable effects but produce intense color only with time and muscle. Prismacolor is one of the widely used brands.
- The Swiss brand **CARAN D'ACHE NEOCOLOR CRAYONS** are water soluble and come in sets and open stock. They have a good range of colors but tend to melt in the sun.
- **OIL PASTELS/CRAYONS** have an oil base and are more generous with their color. The more expensive brands (Caran d'Ache Neopastel*, Holbein, Sennelier) will produce stronger colors and come in sets and open stock. Cheaper brands break more easily but work well if the paper has a bit of tooth. Oil pastel can be sprayed with fixative for layering and if protected can be framed without glass.
- **SOFT/CHALK PASTELS** range from the harder sticks of NuPastel and Rembrandt to the softer, more expensive Schminke* and Sennelier, which is almost pure pigment and will cover the harder pastels. Other brands include Unison and Diane Townsend. The cheapest brands of pastel have less pigment content and create more dust. Many people get harder sets of 24–45 to begin a painting and then layer with softer, more pigmented colors from sets or open stock. Pastel spray fixatives (Latour and Lascaux are best) can be helpful, but the finished surface of soft pastel is always vulnerable and needs to be framed under glass.

Note: * denotes the brands I prefer.

Emilo Lanier, *Trees* (detail), oil pastel, 18 × 24 in.
Oil crayons applied directly to white paper are generous with color.

Connie Smith Siegel, *Stream in Winter*, mixed media (Caran D'Ache Neocolor crayon and acrylic/casein wash on green mat board, with gesso/pumice ground), 14 × 36 in., 1998
The flowing stream is built up over time with acrylic wash and crayon, allowing for subtle layering from visual observation.

CHAPTER NINE

media

Although we have focused on the inner spirit and perceptual source of color, the media you use can itself influence your perception. As you discover the particular media and surface(s) that match your elemental feeling states, your perception can expand and deepen. Your work can come alive under your hands and can attain a tangible, almost magical presence. In this chapter we will explore the characteristics of drawing and painting media as a way to further realize the elemental qualities of the different contrasts we have explored. As you experiment you will discover your own way, led by your own needs.

Emilo Lanier, *Trees*, oil pastel, 18 × 24 in
With the direct simplicity of oil pastel, nature is transformed into planes of vibrating color.

exploring media

Materials for the basic process include light and dark drawing materials, a box of twenty-four or more oil pastels, and/or chalk/soft pastels. Also, (not shown) 18 × 24-inch newsprint or bond paper and a pile of Color-aid papers.

In the preceding pages we have seen the close relationship between the more immediate healing/sensing process work and more developed paintings. Whether fleeting or developed over time, all of these works reflect common elemental qualities. These shared qualities demonstrate a universal language of color, common to everyone.

But despite this commonality, there are differences in the ways we use media. Now that you have experimented with the many ways to access the universal language of color, it is time to discuss the impact of media in your creative process. Your materials are intimate companions and each variation of medium can profoundly influence your work and state of being.

Each medium holds its own promise of magic, but we can become disheartened, even embarrassed, if these promises fade. In frustration, I have often heard people say, "I don't know how to use this medium!" implying there is a right way. I suggest instead giving time to find your *own* way with the medium, giving up specific techniques and expectations for "good" results—at least for now.

And yet specific techniques led to the great achievements of our Western tradition. The secret ingredients of egg

Jan Gross, *Reflections on the Iraq War*, pastel on Canson paper, 22 × 30 in., 2007

Using pastels on Canson colored paper, Jan has allowed her immediate sensation from the basic sensing process to evolve into subtle interactions of color. Underlying the balanced geometry of this piece was an emotional response to conflict and violence, disturbing the peace of nature and the fabric of life.

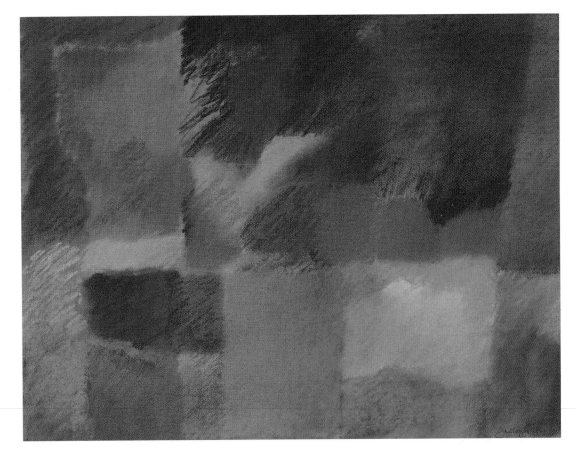

Paper for Colored Drawing Media

Besides the paper for black-and-white media, there are papers created for colored drawing media, bringing it closer to painting. The paper for soft pastel is especially crucial because it is closest to pure pigment and depends on the surface for depth and layering. Colored papers include Canson Mi Tientes*, Fabriano Tiziano, and Crescent papers and boards. Printmaking papers such as Rives BFK (white, cream, tan, and gray), Arches 88, Stonehenge, Joannot, German Etching, and different kinds of watercolor paper can be used directly or primed with acrylic gesso to color or with pumice for texture and to extend layering. Golden or Art Spectrum* pastel ground, in different colors, already includes pumice and/or silica. Colored papers with a prepared surface for pastels include Sennelier La Carte, Wallis, Ersta sand-paper, and Sabretooth. As you explore this wide range of colored drawing media and paper, it may take time to find the combination that works for you.

Note: * denotes the brands I prefer.

Leila Joslyn, improvisation with pastel on tan Sennelier le Carte paper, 2008.
Experimenting with hard and soft pastels just for the joy of it.

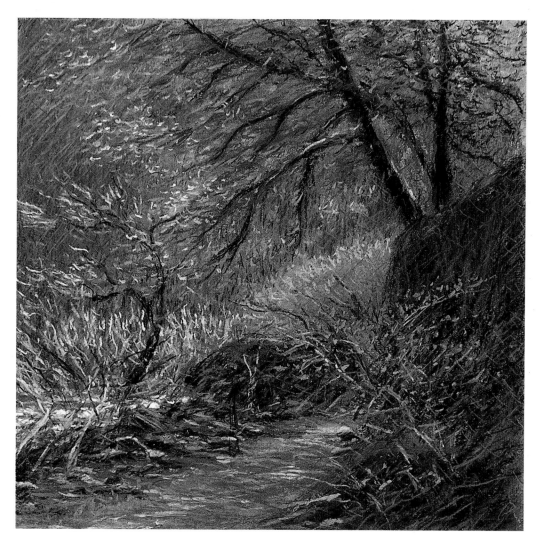

Connie Smith Siegel, *McCloud River, Spring*, pastel, 25 × 25 in., 2003
The purple background of pumice and acrylic on printmaking paper creates an overall color tonality, evoking a fleeting sense of late afternoon light along a spring riverbank. Much of this purple background still shows, preserving the simultaneous effect.

painting media

Connie Smith Siegel, *Muir Beach Overlook*, casein study, 9 × 10 in., 2004

A small casein study (above) on primed paper established the composition for a larger painting on 53 × 55-inch canvas. The painting of Zion at twilight (detail below) was built up of many layers of acrylic and oil crayon on absorbent polyester canvas, highlighted at the end with oil paint.

Zion at Twilight, (detail) acrylic, oil crayon, and oil paint combined, 36 × 96 in., 1994

Each of the different paints has a distinct elemental tendency, relating to the Itten contrasts we have studied. We will begin with water-based paints, as they could be most easily incorporated into your experiments with drawing media.

- **WATERCOLOR**, in either pans or tubes, has a base of gum arabic and is used transparently. For some color contrasts, you may need to add opaque white (China white, casein, or gouache). It is naturally inclined toward simultaneous contrast.

- **GOUACHE**, or designers' colors, also has a gum arabic base but is opaque. Winsor Newton and Da Vinci are good brands. Gouache is inclined toward air and water, but through its opacity it can express contrast of saturation (earth) as well.

- **CASEIN** comes from the curd of skim milk. The expressive range is close to gouache, but it has a more robust quality and can be layered effectively. Although casein was common forty years ago, Shiva is the only brand available now. It is a great paint, but needs the best paper. It tends toward the subtle shimmer of simultaneous contrast.

- **EGG TEMPERA** (traditional) is made by diluting powdered pigment with egg yolk. The paintings are built up on a board primed with gesso using small strokes. Egg tempera was predominant before oil paint and is still used by contemporary artists such as Andrew Wyeth because of its earthy luminosity. Watercolor and acrylic can be a substitute for the powdered pigment.

- **TEMPERA/POSTER PAINT** is delightful to work with and spreads easily, but unfortunately it fades in the light and cracks.

- **ACRYLIC** is a polymer-based medium and resembles the tempera, but with significant differences. It can be spread easily over large surfaces (it is the medium of contemporary muralists) and is permanent when dry (see pages 170–171 for mixing). The first layer of acrylic paint can seem wonderful, but it can grow flatter with each layer. Gel media can help, but they tend to become shiny. I have used egg yolk as a medium instead, which retards the drying time and gives a matte luster. Like casein and gouache, acrylic tends toward the lighter elements. It can seem intense, but oil is more saturated.

- The addition of linseed oil to pigment in the sixteenth century lead to the revolutionary discovery of **OIL PAINT** and the remarkable sense of

three-dimensional modeling and depth we see in Renaissance and Baroque painting. The original gel media of linseed oil, beeswax, and varnish (described by Jacques Maroger) are still used in many representational paintings. However, these traditional media can diminish the shimmery interactions of the warm and cool contrast. To capture the vibration of pure color, which could evoke sunlight, Monet and other Impressionists not only gave up the traditional media but even set their newly acquired tube paints on cardboard to draw out the excess oil. This drier use of oil paint continued with the vibrant contrast of hue of the Fauve painters, such as Matisse and Derain.

Surfaces for Painting Media

Each paint is influenced by the surface you use. Oil is usually painted on cotton or linen canvas, mounted on board, or stretched on stretcher bars, primed or unprimed. Oil paint can be applied to paper or board (Masonite, birch) that has been primed with acrylic gesso—a more absorbent surface. Acrylic paint, being more flexible, can be used on all of these surfaces, as well as many others: plastic, metal, and wood. The other water-based media are generally painted on the paper mentioned for colored drawing media: watercolor paper, printmaking papers, and illustration board.

There is no need to master any of these drawing or painting media but rather to find those that can draw out your natural power and, like a good companion, expand your possibilities. After years of working with the earthy intensity of oil, small casein studies (opposite) brought unity and luminosity to my work. Acrylic washes with Caran d'Ache crayons enabled me to paint flowing water. Pastel captured the diffused light of this coastal area. These discoveries grew from a need for greater connection with natural forces, and much experimenting.

Pat Maloney, *Original Dancer* (detail), acrylic/canvas, 4 × 5 ft., 2007 (top); *Statue in Olema Graveyard* (detail), oil on canvas, 12 × 20 in. (above); *Nicasio Landscape* (detail), Caran D'Ache crayon on green mat board, 12 × 30 in. (below)

Over the years Pat Maloney has explored a wide range of media, from the light and dark drama of oil (above), to the subtle layers of crayon on mat board (below), to the warm and cool vibrancy of his recent acrylic canvases (top). Each medium brought out a different aspect of him. Throughout his exploration of paint and crayon, he has maintained a consistent practice of pen and ink drawing, keeping him in touch with his inner forms and rhythms.

Regina Krausse, oil on canvas, 18 × 14 in.

Contrast of hue matches the intensity of the sun.

Colored paper selections and colored drawing media can immediately reveal your inner color harmonies. Working with paint can extend these harmonies even further but can become frustrating if you can't find the colors that you need. Knowing how to obtain the basic hues of the twelve-hue color wheel from the specific pigments in the tube colors listed on the opposite page is an essential step in this process. Although some hues come directly from the tube, others in the cooler range (especially blues, greens, and purples) need to be mixed. Mixing knowledge is as important as locating the keys on a piano or the strings on a guitar. Here are suggestions for getting started.

Mixing Techniques

Although you can mix paints with a brush, the best tool for precise mixing is a palette knife with a bent handle. Colors can be mixed on a glass palette (preferably), with the warm colors on one side and the cool colors on the other, leaving the center free for mixing. I usually begin with yellow and go clockwise around the circle, adding water or thinner as needed to paint the twelve colors on white paper or canvas.

Each medium has its own strengths and restrictions, both in pigment content and application. Finding the maximum intensity in any of the different media can be an excellent way to compare them. The inherent intensity of better watercolors, gouache, and casein requires better paper. Acrylic is more versatile, but the binder that makes it flow easily also dilutes the pigment content. Because acrylic cannot be revived after drying, the paint needs to be kept moist. After mixing, I put the paint

PAINT MIXTURES (OIL)

YELLOW—COLOR STRAIGHT FROM THE TUBE, I.E., CADMIUM YELLOW LIGHT

YELLOW ORANGE—ORANGE INTO CADMIUM YELLOW LIGHT

ORANGE—CADMIUM ORANGE, FROM TUBE

RED ORANGE—CADMIUM RED (OR EQUIVALENT) INTO ORANGE, OR USE CADMIUM RED LIGHT FROM TUBE

RED—CADMIUM RED (OR EQUIVALENT) FROM TUBE

RED VIOLET—ROSE RED (OR EQUIVALENT) FROM TUBE (PLUS WHITE)

VIOLET—ROSE RED AND ULTRAMARINE BLUE (PLUS WHITE)

BLUE VIOLET—ULTRAMARINE BLUE FROM TUBE (PLUS WHITE,) WITH A LITTLE ROSE RED

BLUE—PTHALO BLUE (PLUS WHITE) WITH ULTRAMARINE OR COBALT BLUE (THERE'S NO TRUE BLUE IN A TUBE)

BLUE GREEN—PTHALO GREEN WITH PTHALO BLUE (PLUS WHITE)

GREEN—PTHALO GREEN INTO CADMIUM YELLOW LIGHT

YELLOW GREEN—A LITTLE PTHALO GREEN INTO CADMIUM YELLOW LIGHT

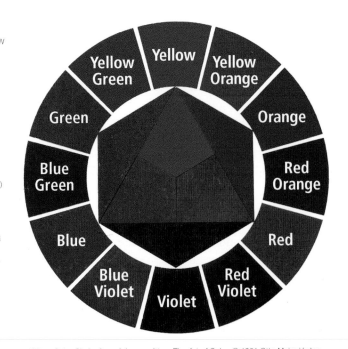

12-hue Color Circle, from Johannes Itten, *The Art of Color*, © 1961 Otto Maier Verlag Ravensburg. Reprinted with permission of John Wiley & Sons, Inc.

on absorbent paper on top of a wet sponge in a plastic storage box (which can be refrigerated). Nothing can match the full-bodied brilliance of oil, but it becomes muddy if not mixed thoroughly.

Tube Colors Needed to Mix a Color Wheel

Here are the minimum tube colors (pigments) you will need in any paint medium to make a twelve-hue color wheel. These colors cannot be created by mixing.

- YELLOW: Cadmium Yellow Light, Hansa Yellow, Lemon Yellow
- ORANGE: Cadmium Orange
- MIDDLE RED (these are the brightest available in each medium): *Casein:* Cadmium Red Medium; *Acrylic:* Napthol ITR Crimson; *Oil:* Grumbacher Red
- RED VIOLET (these are the purest and most permanent): *Casein:* Rose Red, Acra Violet; *Acrylic:* Quinacridone Magenta; *Oil:* Permanent Rose, Gouache: Alizarin Rose Madder (Alizarin Crimson is too brown in any medium).
- BLUE (TOWARD VIOLET): Ultramarine Blue, Cobalt (optional)
- BLUE (TOWARD GREEN): Phthalocyanine Blue (Pthalo), also called by the brand name Windsor Blue. Pthalo colors are strong dyes.
- GREEN (TOWARD BLUE): Pthalocyanine Green, also Windsor Green
- WHITE: Titanium White

Mixing Contrast of Hue

The twelve clearly differentiated colors you obtain for the color wheel are the colors inherent in contrast of hue. After mixing and painting the twelve hue colors, in a row or color circle, try the experiments presented earlier for this contrast—painting a free-form abstraction or painting the world with the colors inherent in the rainbow. This can be an excellent practice for maintaining strong intensity while looking at a world of subtle neutrals. Contrast of hue includes the whole color wheel, but it is important to start with the three primaries. Keep every color vibrant, and separate, without shading and without any neutrals, including black. Painting with contrast of hue is also a valuable practice for mixing and painting the next contrasts—from the electricity of warm-cool contrast to the subtleties of contrast of saturation and simultaneous contrast.

Connie Smith Siegel, color wheel, casein on illustration board
Itten's color wheel is realized in dabs of paint (opposite) and in my painted color wheel (above).

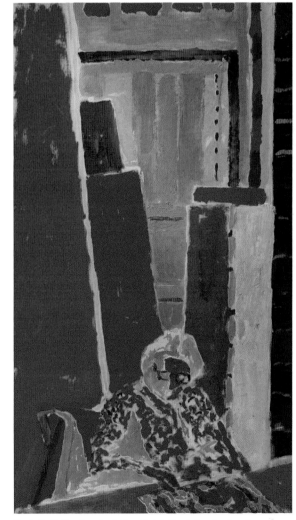

Connie Smith Siegel, contrast of hue study in the studio, oil on board
Contrast of hue transforms a drab storage area.

Mixing Contrast of Warm and Cool

After mixing colors for the twelve-tone wheel, concentrate on the core colors at the heart of the contrast of warm and cool: the complements red-orange, blue-green, and violet, as illustrated on the checkerboard (left). To achieve maximum color vibration, the warm and cool colors must be the same value. This means that the blue-green and violet will need to be mixed with white (or diluted, if transparent watercolor) to match the value of the orange, because orange cannot get darker without becoming brown. The chart on page 61 can help you clarify this concept. By running a horizontal band across the chart at the value level where red-orange is at its most intense, you can see that the inherently darker blue green and purple have become lighter. As you add white (or watercolor transparency) to these cooler colors your eye can tell when they match the red-orange by the "electricity" they can generate. It is often surprising to see how much lighter the cool colors need to be to fully vibrate with orange.

Mixing these colors can be challenging, but once accomplished this electric interaction of warm and cool can open a world of color expression. This is the source of magic in color, even when we move into the gray range. Casein, acrylic, and soft pastel can be effective, although oil (without any medium) was the original medium of the Impressionists.

It is especially important to know how to mix the color purple (from blue-violet and red violet), as it is an important catalyst in warm and cool, vibrating as a cool to the orange, and warm to blue-green. Purple comes in tubes, but you still need rose red and ultramarine blue to move it warmer or cooler.

Mixing Contrast of Saturation

Mixing the neutrals for contrast of saturation requires all of the tube colors listed on the palette and also knowledge of how to mix both contrast of hue and warm and cool, except that now we are aiming for the minimum intensity of each color.

Begin by mixing neutrals from the complements, noticing how each pair makes its own gray, black, or brown depending on the balance of warm or cool and the amount of white. These mixtures are generally more luminous and varied than those using black or brown from the tube.

After mixing a range of neutrals, closely match the color of a paper selection of the element of earth, or look closely at a natural subject, such as bark or a stone. As you mix the color, you might be surprised at how much a hue needs to be modified to finally match the true color you are seeing. But when it arrives, you will find this color has a particular luminosity, a distinctive identity all its own. This is an excellent exercise for mixing all media, especially oil paint, working with the flat planes typical of contemporary painters such as Braque and Morandi. The simplicity of Paul Klee's checkerboard/type pattern (see page 109) is a good model for your composition. Klee's colors reflect his love of the oft-forgotten neutral colors of the world. To be reminded of these colors, look into a mirrored kaleidoscope, whose repeated patterns create magic even in the dullest corner. Matching the world through the process of seeing and mixing can bring a meditative connection, and expand your perception of the world around you.

Checkerboard, from Johannes Itten, *The Art of Color*, © 1961 Otto Maier Verlag Ravensburg. Reprinted with permission of John Wiley & Sons, Inc. (top); Margorie Law, extended study (detail) warm-cool, acrylic (above)

Red-orange, blue-green, and red-violet vibrating at the same value level activates the eye.

Mixing Simultaneous Contrast

Because simultaneous contrast integrates all the elements, it requires knowledge of how to mix all the contrasts described so far. You must be especially attentive while painting, because colors mixed on the palette will often change on the painting in relation to other colors, especially on a colored ground. A small stroke of a neutral color (of the same value) can vibrate immediately on the colored ground, creating magic. But this effect can disappear if the neutral area gets bigger; it often becomes necessary to bring back the background color. Finding this precarious balance takes constant attention to the whole painting and often many adjustments in mixing. Sometimes I leave much of the ground still showing rather than lose the unity of the first color effect (see page 167), as it can take many months of layering to find it again. Pastel, acrylic, gouache, and casein naturally tend toward simultaneous. Oil is effective when mixed carefully.

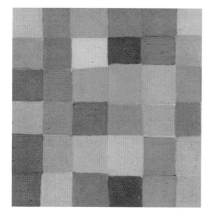

Regina Krauss, color study (detail), oil, 1997
Red and gray vibrate against browns.

Linda Larsen, oak study (detail), oil on canvas, 2007
Linda's close observation of an oak reveals a world of browns, grays, and black. The paint is almost as thick as the bark itself.

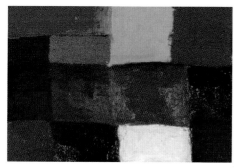

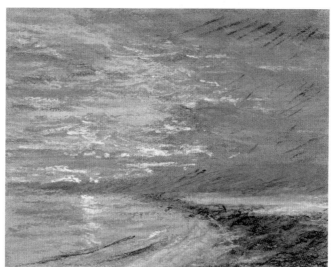

Connie Smith Siegel, checkerboard (detail), casein on primed board (far left); *Sunset Stinson Beach*, casein on printmaking paper (primed with purple acrylic, with pastel added later), 6 × 8.5 in. (left)
The casein checkerboard evoking a winter sunset (far left) is echoed years later in the ocean sunset (left).

exploring colored paper

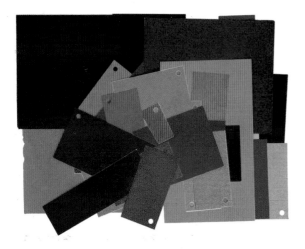

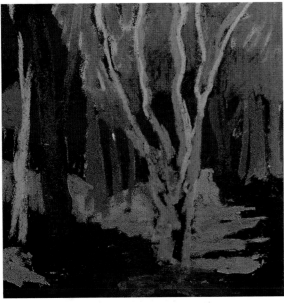

Sandy White, paper selection for *Walk in the Forest, II*, paper (top); *Walk in the Forest, II*, pastel on Sennelier paper, 8 × 10 in. (above)

From the infinite color pile, Sandy's color chord (top) becomes a vibrant landscape (above).

The use of colored paper selections is fundamental to our explorations, immediately revealing inner color harmonies for self-discovery, preparation for painting media, or, for some, an expressive medium in its own right.

Creating a Color Pile

The best basis for the color pile is a color selector called Color-aid, a packaged set of color cards utilized largely by commercial artists and available in a variety of sizes in art stores or on the Web. These intense silk-screened color cards are numbered on the back and are arranged in their proper order on the color wheel, each with its corresponding shades, tints, and related grays. It is best to begin with Color-aid cards, as they offer a balanced selection of colors, from light to dark, warm to cool, intense and muted. I recommend you buy a Color-aid Selector containing three-hundred and fourteen 3 × 4.5–inch color cards. You can cut the cards in different-sized shapes if you want size variation for your color chords. Color chips (especially neutrals) from paint stores can be added to your Color-aid set later.

It is helpful to have extra sheets of paper (mostly white) available to create a neutral background for the selected colors, especially for more subtle color combinations. I store the color chips and extra paper in a cardboard folder, with clips holding the edges to keep from moving while carrying them. Individual color selections, put on cardboard (about 14 × 18 in.) and covered with a piece of Plexiglass with clips on either side, can be stored and viewed as well.

The geometry of these commercially made color swatches may seem limiting, but the squares and rectangles of the color selectors create a neutral structure for the dynamic interaction of colors. Paradoxically, the limitations set by the straight lines of the squares and rectangles gives us the freedom to concentrate just on pure color. The powerful voice of color, often neglected in depicting images and/or developing specific shapes, can have our full attention.

When making a color chord some people carefully arrange their papers, and others leave the colors just as they are, spontaneously lifted from the pile. Often a larger color underneath the others can set the tone, with the others contrasting, or echoing it. Some colors are prominent, and others are hidden, barely visible. Each arrangement gives a different feeling to the combination. These variations are important to follow as we construct a painting or understand the emotional message of our color choices. In my observation, the order created by the interaction of hand, eye, and intuition is always impeccable. I never question these instinctive choices.

exploration through collage

As you experiment with the Color-aid color cards, you may feel tempted to tear these color swatches into shapes that correspond to what you are feeling. This natural impulse can develop into an important art form: the collage.

There is a vast world of paper you can use in collage. In addition to the more expensive papers from color selectors and the colored papers mentioned on page 167, there are specialty papers with exotic textures and colors, thinner origami papers, and even tissue paper. Remember that for more permanent collages, the paper *must* be archival (acid free) and colorfast.

Adhesives for collage can vary, from temporary scotch or masking tape, rubber cement, and glue sticks, to permanent rice-based glues, such as Yes brand. Thinner papers can be glued from the top with matte acrylic medium or Tacky Glue, thinned with water.

You can start your collage anywhere, placing torn or cut paper on a backing of cardboard or stiff paper. Trust your first arrangement and move on to another, or work for some time on one piece, building it up, tearing it apart, and putting it together again, until it feels complete. Although collages can be planned, their fundamental advantage, in terms of self-communication, is changeability—combining unexpected elements and allowing for the spontaneity of random choices.

The possibilities inherent in collage can be endless, almost overwhelming. Adding images from reproductions and magazines can add an important dimension of meaning, especially when working with art and healing. The boundaries of the picture plane can be extended to include real space, as in contemporary art forms known as installations. The tangibility of collage and installation is exciting, challenging assumptions about what drawing and painting should be. After experimenting, you might find yourself drawn to collage or installation, or you may wish to return to the individual touch and color inherent in drawing and painting media.

Jan Gross, *Improvisation*, collage and pastel (detail), 2000
Jan combines the immediacy of drawing with the inherent structure of collage.

You may feel that there is no real necessity for remaining visually truthful or even structurally truthful in relation to the moment. There is always a bigger truth undiscovered—unsaid— uncharted until you meet it.
Kimon Nicolaides,
The Natural Way to Draw

Beatrice Darwin, *Vertebrae*, collage, 12 × 12 in., 1998
Beatrice often gathers her collage material from everyday life. Here, she has combined a medical record of her spinal examination with abstract shapes and drawing. Her sense of adventure is a model for the transformative spirit of color—trusting what is alive in the present moment.

index